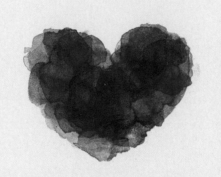

Love What Matters

REAL PEOPLE. REAL STORIES. REAL HEART.

THRESHOLD
EDITIONS

RedSeat

NEW YORK LONDON TORONTO SYDNEY NEW DELHI

Special thanks to Colin Balfe, Kevin Balfe, Alyse Powers,
Marianna Di Regolo, Lisa Olsen, LJ Herman,
and the entire team at Red Seat Ventures.

Threshold Editions
An Imprint of Simon & Schuster, Inc.
1230 Avenue of the Americas
New York, NY 10020

First Threshold Editions hardcover edition May 2017

THRESHOLD EDITIONS and colophon are trademarks of Simon & Schuster, Inc.

For information about special discounts for bulk purchases, please contact Simon & Schuster
Special Sales at 1-866-506-1949 or business@simonandschuster.com.

The Simon & Schuster Speakers Bureau can bring authors to your live event.
For more information, or to book an event, contact the Simon & Schuster Speakers Bureau
at 1-866-248-3049 or visit our website at www.simonspeakers.com.

Interior design by Timothy Shaner, NightandDayDesign.biz

Manufactured in the United States of America

1 3 5 7 9 10 8 6 4 2

Library of Congress Cataloging-in-Publication Data has been aplied for.

ISBN 978-1-5011-6913-7
ISBN 978-1-5011-6914-4 (ebook)

FOR PATRICIA,
WHO PROVED THAT LOVE
IS WHAT REALLY MATTERS.

We all get stuck in the routine of life. Your day starts when the alarm goes off, then you take a shower, drink coffee, take the kids to school, commute to work, eat lunch, work some more, commute home, have dinner, watch television, go to bed . . . rinse and repeat.

The specifics may be different for each of us, but the result is usually the same: a tendency to prioritize short-term checklist items over things that really matter. We all intuitively know that an unexpected bill or a long wait at the grocery store is not something we're likely to remember on our deathbeds, yet it's hard to think beyond the daily frustrations and errands. It's hard to get perspective.

Occasionally, something happens that snaps us out of the routine. Something that reminds us of the people we aspire to be. Sometimes it's as simple as an inspirational quote shared on social media (usually something about traveling more and worrying less—and almost *always* involving wine), but then the moment passes and it's on to the next post, television show, or to-do item on an endless list.

What's most frustrating is that the things represented by those quotes or on those ubiquitous "rules of life" posters are the very things we want most in life. For example, the author and speaker Robin Sharma once wrote "The Rules for Being Amazing," which include:

Be strong.
Show courage.
Be kinder than expected.
Shatter your limits. Transcend your fears.
Inspire others by your bigness.

Yes! Who *doesn't* want to live like that?

But how many of us can honestly say that we prioritize those kinds of things? Who's thinking about shattering limits or transcending fears when you've got a flat tire, your house is a mess, or your kids are home sick from school?

The Love What Matters platform grew out of this recurring internal conflict that most of us face: How do we reconcile the person we want to be with the reality and challenges of everyday life?

Self-help books are great reminders of the things we can do to improve ourselves over the long term, but nothing is quite as motivating as seeing others be the type of person you want to be. Reading "be kinder than expected" isn't nearly as powerful as witnessing a stranger buy lunch for a homeless man. Reading "show courage" falls flat compared to a photo of a ten-year-old boy with cancer bravely going through chemotherapy.

These moments of ordinary people doing extraordinary things are the ones that can truly change us. They are raw, emotional, authentic, and personal—but, most of all, they are relatable. We see them and it dawns on us that these aren't superheroes; these are people just like us.

Love What Matters exists to spread these stories far and wide, to celebrate the love and kindness and compassion they represent—while reminding us that these things do not happen by default, they're a daily choice.

The moments we amplify on our platforms are also meant to serve as a balance to the kinds of things we hear about in the news every day. We all hear stories of bullying incidents at school, but how often do we hear stories of children who put peer pressure aside and show true kindness to each other?

Grant, a six-year-old with a port-wine stain birthmark on his face, went to first grade and met Tucker. Tucker, like most kids, asked about the birthmark. Then, instead of making fun of it, he said, "Well, your

birthmark is really cool." Grant's mom later wrote that, for the first time, her son felt supported and cared for and that he had the biggest smile on his face. (See page 32 for this story.)

We hear about racial tensions flaring and about police officers being at the center of a growing storm. Then we see a photo of a state trooper kissing his daughter on her first day of school (see page 28) and are reminded that these men and women are just like us: husbands and wives, fathers and mothers.

If you're a mom, you already know there are times you feel like the only person in the world who is struggling. The "perfect" world of social media only helps reinforce that. But, guess what—everyone is struggling. No one has it figured out. One mom's realization that her children will ultimately remember they were fiercely loved far more than her mistakes as a mom has inspired thousands of others to refocus on what really matters. (See page 67.)

These stories are bigger than any one of us, yet they represent *every* one of us. Our vulnerabilities. Our pain. Weaknesses. Successes. Beauty. Flaws. Generosity.

And, of course, our hopes and dreams about who we aspire to be.

We're thrilled to have you as part of the Love What Matters community of mothers, sisters, fathers, brothers, wives, husbands, doctors, nurses, cops, teachers, and millions of other everyday heroes around the world.

We celebrate kindness, compassion, hope, forgiveness, and love.

But most of all, we celebrate *you.*

So, the next time you witness something extraordinary (or, better yet, the next time you *do* something extraordinary), please be sure to tell us, so that we can tell the world.

—THE TEAM AT LOVE WHAT MATTERS
Tell Us Your Story at LoveWhatMatters.com

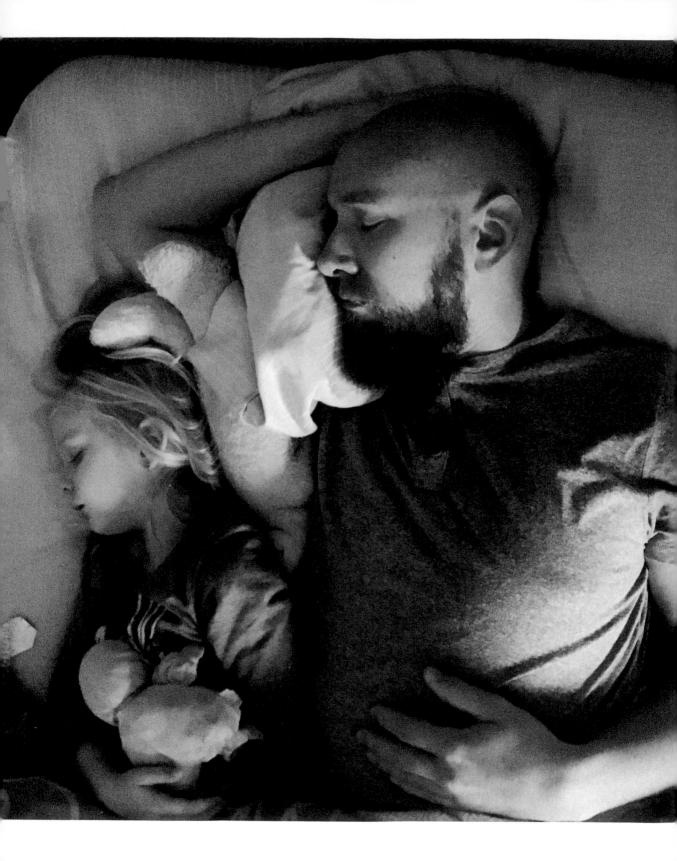

this gorgeous moment

YESTERDAY

was a grumpy day for me. I didn't feel like being a mommy. I didn't feel like making meals, or doing schoolwork with my kindergartner, or doing laundry.

I didn't feel like being happy.

I wanted to close myself in a dark closet and feel silence and quiet for just one minute.

I was miserable all day, and then I snapped at my husband before bedtime because of selfishness.

We went to bed grumpy at each other, and it was sad and pathetic.

But this morning I woke up and rolled over to this picture.

My heart.

Moments like this are so easy to cherish; it's so easy to choose happiness and love in beautiful moments like this.

But real love chooses happiness in the ugly moments too.

Real love chooses to cherish even in the frustrating moments.

A time could come where those moments are taken from you, and you would want only to have them back.

Choose love.

Choose patience.

Choose to cherish.

Also, I'm so glad I woke up early, or I would have missed this gorgeous moment. **—JOANNA SCHEUERMAN**

JORDYN KOCH: I really needed to read this today. I'm going through some hard times myself. Thank you for sharing this.

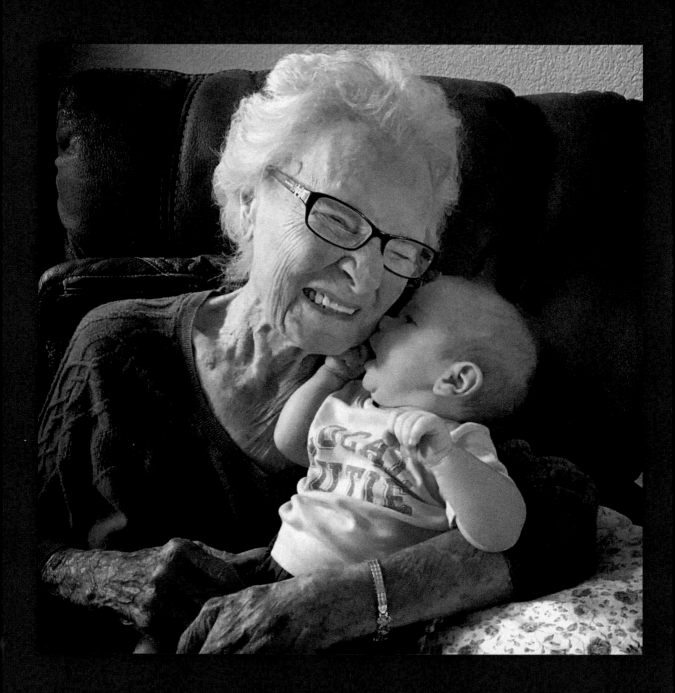

her beaming smile

ON JUNE 6, 2016, our son, Weston Alexander, was

born on my great-grammie's hundredth birthday. I had the honor of capturing the timeless moment when they first met! Tears of joy ran down my face as I tried to look at the camera screen for the perfect snapshot. My heart was about to explode! Tears also began to fill my great-grammie Dorothy Arlene Martell's eyes as she held Weston and gently kissed his head. Her fragile skin touched Weston's flawless complexion. Smiles from ear to ear filled our hospital room during her visit, and God was receiving the utmost praise for His precious gift of a new baby boy and the answered prayer of being born on her hundredth birthday.

Just a month prior, she had experienced the untouchable pain of losing a son. But when she held Weston for the first time, her beaming smile was contagious. "How wonderful it is to be celebrating life after so much heartache and loss!"

My great-grammie passed away on October 14, 2016, so I wanted to share with you a few pictures of my precious grammie and Weston and a few of their moments together.

—ALYSSA HEISER

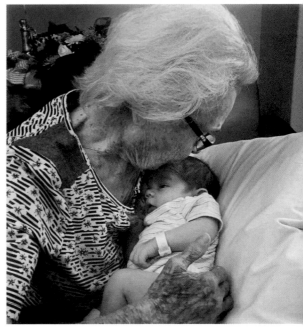

3

I MADE THIS blanket for my daughter for her fifth birthday. My mom and grandma always sang this song to me when I was a little girl, and I continue to sing it to my own kids. Over fifty hours, over three thousand yards of yarn, over one hundred ends to weave, and an endless amount of love went into making this, and it will be cherished for a lifetime. **—ASHTYN RUYSCH**

SEE THIS MOMENT?

I've never experienced a moment like this. Yesterday was the first day my five-year-old autistic son met his new autism service dog, Tornado. We are Americans who live overseas in Japan and have prepared for nearly two years to meet Tornado.

This picture captures the face of a mother who saw her child, whom she can't hug, wash, dress, snuggle, and touch freely, lie on his new service dog of his own free will, with a purposeful, unspoken attachment. This is the face of a mom who has seen her son experience countless failed social interactions on the playground in an attempt to have a friend. Any friend. Any kind of connection. She has sat with her son while he has cried at night for months because he has no consistent connections outside of the family, no matter how hard he tries and no matter what he works hard on in his autism therapies. It doesn't transfer to the naturally occurring world for him. And now she is sitting behind her son, silently watching this moment, with the air sucked from her lungs and no words to say.

It's worth every fight for services for my son, every diagnosis, every new provider, every dollar spent, every paper filled out, every school meeting, every shed tear, every step forward, every step back, and every wonder of the unknown future. Somehow, because of this—because of Tornado—I know everything will be okay. As a mother, I have seen countless challenging and painful moments my son has encountered and have cried countless more tears. Yesterday, however, I cried for a different reason. It is a feeling that is indescribable. **—SHANNA NIEHAUS**

RITA PAULINE: I used to train service dogs for children with autism. People always ask, "How can you just give up a dog you spent almost two years excessively training?" . . . This—this is how!

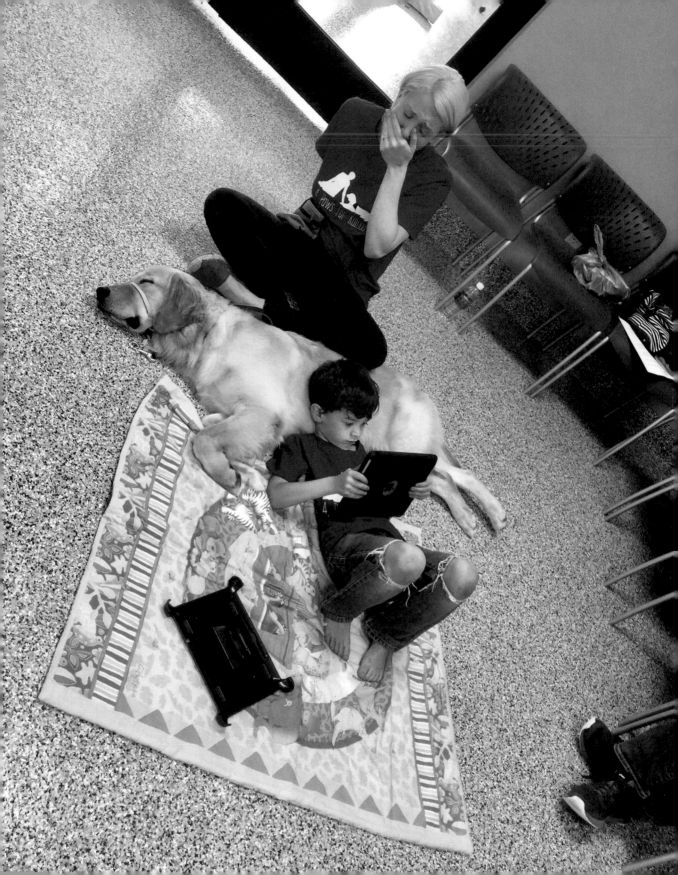

WHAT MATTERS
all will be OK
LOVE

CANDACE CALDWELL: The dog that gave my son words . . . Big hugs to this momma. We prayed for this moment . . . and God sent us a dog.

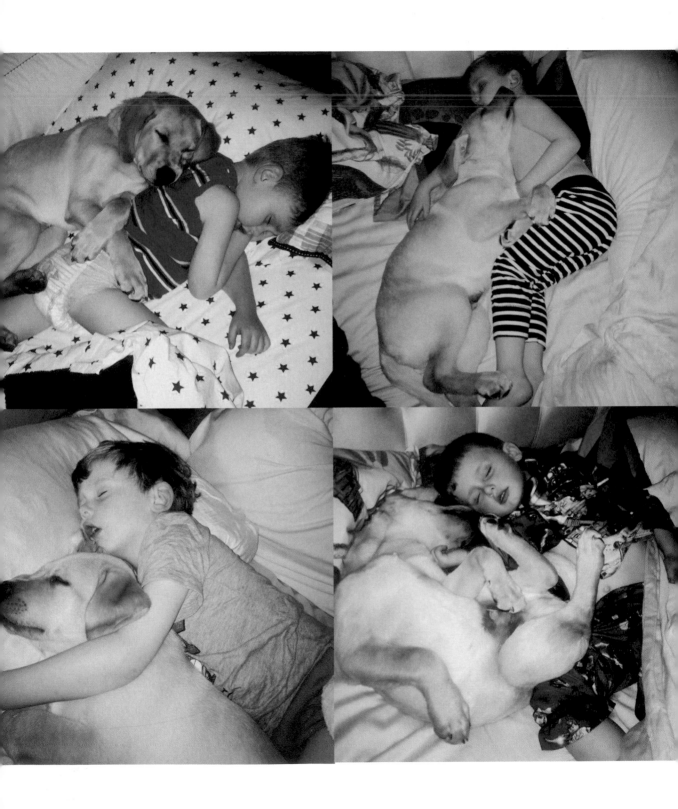

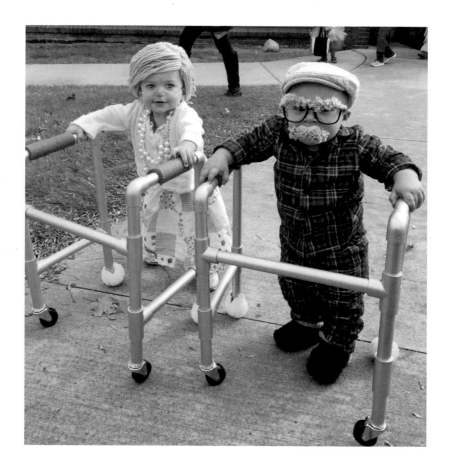

MY SON and my niece are three months apart. They adore each other. It's only fitting that they have coordinated costumes for their first Halloween. —AMANDA MADONNA

take the photo

DEAR MEN: take the photo!

It doesn't matter what she looks like, or if she tells you no—take the photo. You may not think about it often—or at all, honestly. But how many photos does she capture of you, of your family, and of the life you've built? But when she is gone, those photos won't show your children the woman who was in front of the camera.

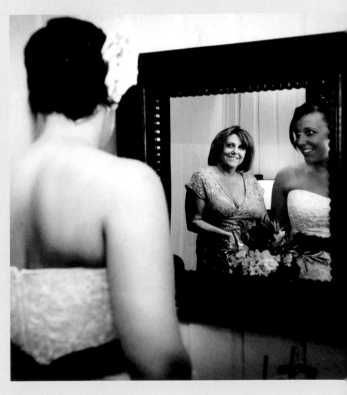

Take the photo. Messy hair, no makeup, or a dirty old T-shirt won't matter to your children when she is gone someday. What will matter is that you loved what you saw enough to take a photo, to document it, to preserve that moment in time of the woman you love. No woman wants to look back at a lifetime of selfies. Do what she does for you every day and snap a few moments.

Be proud. Take photos of her. Before kids and after.

Just take the photo!

—KAYLIN MAREE SCHIMPF

AIMÉE STORM: Take the photo, but don't post it on social media without checking with me first. ;)

11

TODAY

I woke up feeling like I had a hangover. I'm starting my four-day break from the ICU after having worked six of the last eight days. I drag myself down the stairs and start cleaning the house, as I normally do on my days off. I glance at myself in the mirror at the bottom of my staircase. Horror. My face blatantly shows the pure exhaustion that I feel, and my hair looks a complete mess. "Thank God I'm off work today, and my patients won't have to see this worn-out version of myself" is my first thought.

People who aren't nurses always tell me, "You work only three days a week? Wow! That must be great! I wish I had your schedule!" "Only" three days a week? *Only!?* I wake up at four thirty in the morning, shake off my fatigue, drive an hour to work, and then begin my scheduled twelve-hour shift. Twelve often turns into thirteen hours or even more depending on the patient load and if I've been able to keep up with my charting. When I'm done and finally clock out, I drive home, arriving around eight at night. I strip out of my scrubs and collapse onto the couch, where I snuggle my cats and tell my husband about my day until I pass out from exhaustion. I slip upstairs to bed, to the disbelief of my husband that I could possibly be so tired, and I set my alarm and prepare for my next shift.

"Only" thirty-six hours a week. But does anyone who's not a nurse know what those thirty-six hours consist of? Juggling all my nursing tasks for each individual patient while also trying to communicate with the doctors, pharmacists, respiratory therapists, physical therapists, occupational therapists, social workers, our aides, the patients themselves, and their families? Yes, that's right, I communicate with all of these people on a daily basis. I am personal coordinator for my patients. I am their voice; their advocate. I must be aware of my patients' needs at all times. Room 101 is going upstairs to catheter lab at 0900. Room 102 wants his pain medicine at 0915. Room 103 needs to be turned at 0930. Got it. My mental checklist is a never-ending dynamic that I must prioritize and rearrange constantly.

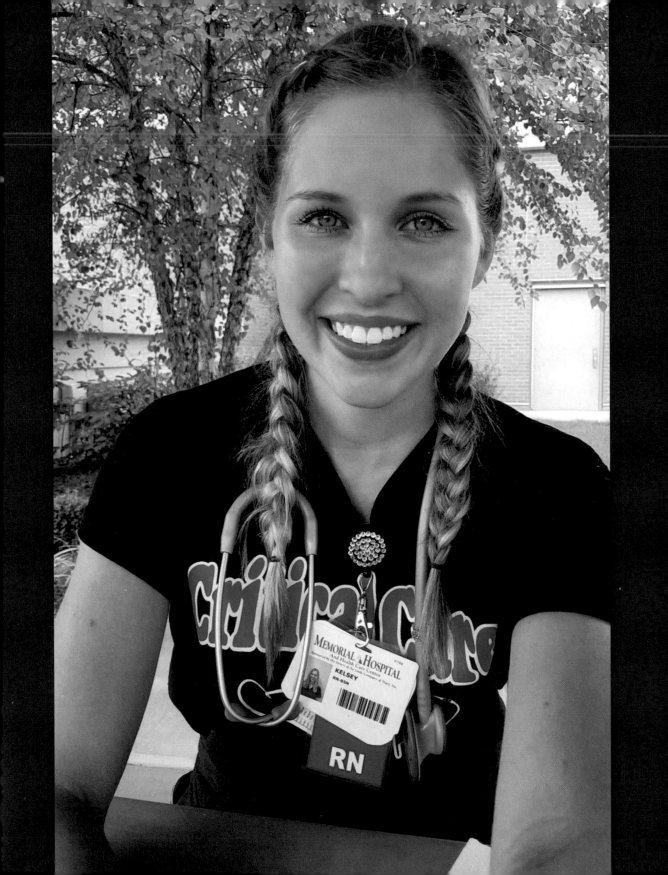

WHAT MATTERS
still-smiling nurse

LOVE

My job is scary. Always thinking, always analyzing, *always* aware of my actions. I could cause a patient to lose their life if I am not thinking critically about everything that I do and every medication that I give. Is this dosage appropriate? Does this patient need this medication? It is all my responsibility to keep the patient safe.

Even when I am doing everything that I can, it isn't always enough. I've had family members displeased that I took a little longer to answer a call light. I'm sorry that I couldn't get you a Coke right away, but I was busy titrating a lifesaving medication in the room right next to yours. I have been asked by a family member if I am qualified to even *be* a nurse—surely I'm too young for that. I have been told that I am too weak to help lift a patient, when in reality I can lift more weight than I weigh. Nursing is hard. I take all these comments and offer a kind response to remain professional even though it can make me feel really small at times. Not feeling appreciated is hard when all I am trying to do is help.

I have been there when a patient said their last words before being intubated and never being able to come off the oxygen vent. I have been there as a patient has taken their last breaths on the earth. I have been there when a patient has decided that their body can no longer fight, and they would like to receive comfort care. I have provided comfort care as family members are silent, with tears streaming down their faces, while I turn the lifeless body of their once-resilient family member. I have been there when a doctor has told a healthy, active patient in front of their spouse that they have stage IV cancer and will not survive. I have stood and held my tears to remain strong for family members who have had their hearts shattered by the news that their loved one will not be coming home again. I have sobbed on my way home from work because my heart is shattered too. I am so sorry that you have to go through these things. I am so sorry that your loved one has cancer. I am so sorry that the doctors and I couldn't get your loved one to wake up after being sedated on the ventilator.

I am human. I care about my patients. How could I not? My heart breaks along with my patients and their family members. Then I go home and try to pretend that I have not been broken during my shift. I don't want to burden my husband with my sadness, and I need to pull it together so I can go back to work in the morning and do it again.

So how do I do it? How do all nurses do it? How do we manage "only" thirty-six hours a week? Because nursing is beautiful. I have been there when a scared patient on a ventilator woke up, so I held her hand and told her that everything would be okay. She could not speak because she had a lifesaving breathing tube down her throat. Somehow she managed to grasp a pen with her weak hands and write, "I love you guys." My heart exploded with joy. I have provided comfort to someone when they were far from comfortable. I have been there when a patient has come off a ventilator after a whole week, and watched as they cried and said they were so happy to be alive. I helped bring that person relief. I have bought lip gloss for an elderly patient whose son forgot to bring in her lipstick. The smile on her done-up face was priceless as she put on the lip gloss to complete her look. I have made a patient genuinely happy even though she was sick and in the critical care unit. I have been there providing comfort care to a dying loved one, and family members have hugged me and thanked me for being the angel that their family member needs. Nursing is beautiful. Life is beautiful. I watch lives change, I watch lives end, and I watch lives get a second chance because of the care and medicine that I have provided.

Nursing is hard. Nursing is stressful. Nursing is exhausting. It drains me both physically and mentally. I come home tired, sweaty, and defeated. Not all days are good days. Nursing is not all sunshine and rainbows. But nursing is my life. I dedicate my life to saving the lives of others. There are those breakthrough moments when a patient recovers miraculously, when a patient holds your hand and tells you how thankful they are for you, and when a patient and I can share a good laugh. The pride I feel when my patient came

still-smiling nurse

in on a ventilator but walks out at discharge makes it all worth it. All the wonderful, precious moments are why I love nursing. The great moments are what get me and my coworkers through the long, difficult twelve-hour shifts. Thank God for fantastic coworkers. My coworkers are like my family. I know that they understand the mental turmoil that I go through after a hard day. Only nurses understand truly what other nurses go through.

So the next time you want to tell a nurse that it must be great to work "only" thirty-six hours a week, please be mindful of what those thirty-six hours are like. Give a nurse a hug today, and be thankful that we continue to do what we do, and don't judge us when we drink a little extra wine. If it were easy, everyone would do it.

Sincerely,

The exhausted but still-smiling ICU nurse.

—KELSEY VAN FLEET

 JACKI TEETER: I don't know how you do it! (Understand that when I say *you* below, it is in the collective sense. :))

You wiped my brow as I came to back in my hospital room after a simple surgery had turned into major surgery, leaving me shivering and reacting poorly to morphine.

You, a couple years later, after I'd been hit by a car, held my hand and murmured to me as seizures ravaged my body repeatedly for hours and then days, leaving me stupid, scared, and confused.

You remembered me each time I was readmitted because the seizures were out of control and the side effects debilitating. I was a "failing" patient.

You stayed by my bed as long as you were able after my heart stopped and restarted from having gone into tachycardia.

You wiped my bum and changed my sheets as I murmured in shame, and you didn't make me feel terrible—just clean, dry, and safe.

You held me carefully as I retched again and again. You even adapted by leaving a little container on my stand so that I could retch accurately (sort of) if you weren't close by. Yeah, you changed *a lot* of bedding, and I got to watch many folks clean up my messes.

You called me *"mija,"* "darlin'," and "gooseberry."

You were patient when I couldn't remember my words and simply wept in frustration, feeling weary and beaten.

You came and talked to me when you could and laughed at my crazy attempts at explanations of my pain-med-induced nightmares that made me scream in my sleep. And I loved the sound of your laughter. It was a small gift I could give to you in the crazy microcosm of the intensive care unit.

You stroked my brow with calm care until I fell asleep again and kept my door open so I wasn't so alone.

You sneaked me sections of orange because you knew I hated canned applesauce and Jell-O.

You lined up all the nurses and clapped for me the last time I was discharged and told me you would miss me but that you never wanted to meet again in the hospital.

You cared, preserved my dignity, and gave me a lot of faith when I felt hopeless and helpless.

You are someone whom I hope to see in the park or at a baseball game or at the grocer, and to *you* I will deliver an enormous "better than ever" hug.

You are part of why I can thrive today. For everyone who hasn't articulated it or doesn't understand, there are those of us who do.

Thank you.

And though they have never had to take care of me to this extent, this collective *you* are part of the community that my sweet nurse friends Kristin and Steve are proud members of.

WHAT MATTERS
a sunflower
LOVE

LAST NIGHT I bought a sunflower to put on the windshield of someone
I'm smitten with. After some consideration, I decided not to, since we had been
on only one date, the night previous. Don't want to come off too strong, right?
Anyway, I grabbed the flower on my way out this morning with the intention
of giving it to someone on my way to work so it didn't die alone. What
happened next has left me changed in ways I don't even have words for yet.

While I was sitting and drinking my morning joe at the coffee shop (which
I typically take to go), I saw a woman reading something with tears quietly
and quickly sliding down her pale face. It was like there was a magnet in the
sunflower that was being drawn to her, because I knew in that moment that she
was who I was going to give the sunflower to; she was who I *had* to give it to.

When I got to her table, I said, "Hey, pardon me. I have this sunflower
that I was hoping to give to someone special, and that someone I had in mind
didn't work out, but I can feel that you're special too, so I want you to have it."

Before I could even hand her the sunflower, this complete stranger flew
into my arms with tears flowing and gratitude spewing, as if I were someone
she'd once loved and lost. It's what she said next that I'm still trying to grip.

She was crying because her fiancé had died the week before, just months
before they were going to get married. On their first date, he brought her a
sunflower and, from then on, got her sunflowers—never roses—because she
was the light of his life.

Today, through me, he was able to show her that she'll always be the
light of his life and how we as humans have a message to carry that goes far
beyond words.

I'm shaken, awaken, and feeling raw. You never know how much a simple
gesture of giving someone a $5 flower will change their life, as well as yours.
Life is about giving and being of service to others. I challenge you all to find
a way to make someone else's life just a little bit brighter today and be of
service. You never know the impact you could have. **—DANNY WAKEFIELD**

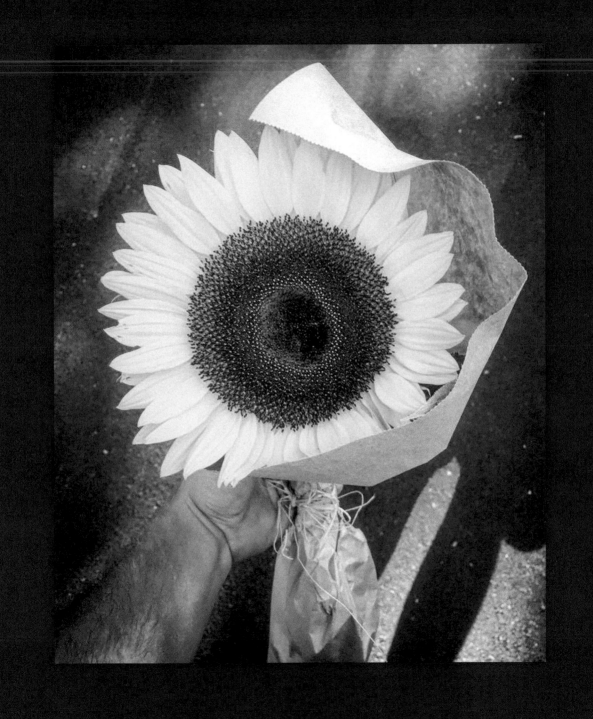

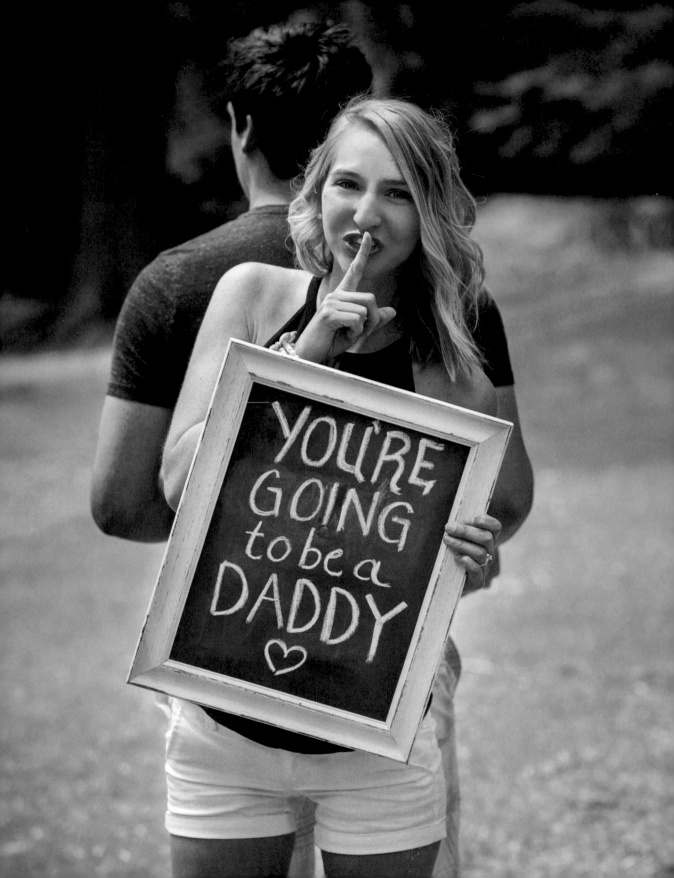

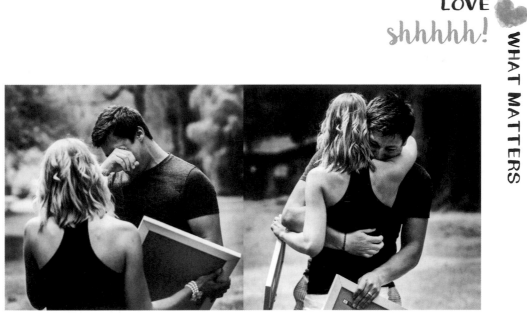

WHEN

Brianne Dow got pregnant, she knew she wanted to do something different to surprise her husband. Under the guise of a free photo session in the park, Brianne brought in Samantha Boos, a photographer.

Samantha asked the couple to write a few words that describe each other. Brianne wrote, "You're going to be a daddy!" on her board. **—SAMANTHA BOOS**

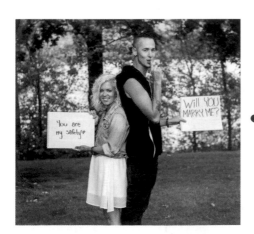

KIMMI DAVIES PETERS: Son did this at a family gathering photo shoot for his marriage proposal. She had no idea! It was so awesome.

21

SITTING

in Taco Bell today, I laughed to myself as a group of young boys came stumbling into the air-conditioned restaurant with loud voices, smiles, and a craving for a taco. But as they all sat down at a table, I noticed that only one of them ordered anything. The other three sat and stared at the menu with hungry glances.

As time went on, they began having conversations about school, girls, and about twenty other subjects. Suddenly the man who was sitting in the corner of the restaurant came over to stand over the table. As the boys shrank back at the sight of this six-foot-five giant, the words that issued forth made my day: "Y'all want a slushie? Come on up here; let's get you guys something."

The three boys jumped out of their chairs, ran to the counter, and not only happily ordered slushies but also found that the stranger offered to buy them food, too. The man asked the cashier if he could pay in advance, as he needed to get back on the road. Card swiped, a good-bye given, and this gentleman quickly went for the back door without asking for a thank-you from the young boys. I nodded silently to him and flashed a smile as a signal that he had been seen. He lifted a hand in farewell toward the counter, and with smiles touching both sides of their faces, the little dudes all turned and yelled, "Thank you!" as he slipped out the door and jogged to his semi parked at the side of the building.

Today love and kindness looked like a twelve-pack of soft tacos and three Starburst Freezes. **—JOSHUA WALKER**

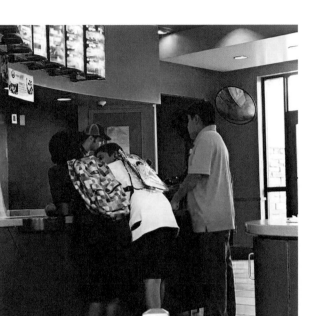

♥ **MISTY BURER:** My husband and I were at Babies "R" Us getting a baby gate and a fetal monitor, but our card was denied, so we had to leave them behind. As we were walking to our van, the people behind us in line called out to us, saying that we'd forgotten our bags. They had bought the gate and monitor for us! We were so blessed. I listened to my baby for hours!

♥ **TERRA WHEELER:** One time my card was declined at Walmart when my son was an infant. I was trying to buy diapers and wipes, but I had forgotten that an auto draft was coming out that day as well. A woman in line behind me paid for the items and a fifty-dollar gift card for the "next emergency." It changed the way I see people forever.

23

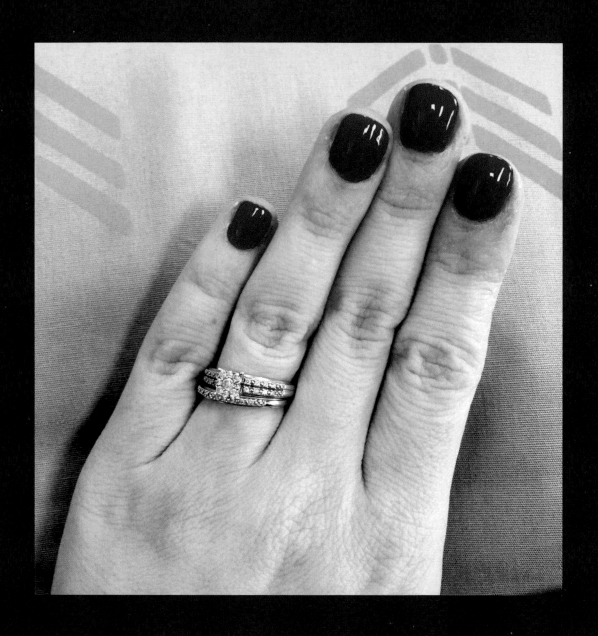

small ring, big love

YES, I know that my wedding ring is small.

Friends and family often ask me when I'm going to have it "upgraded." After all, it doesn't represent the level of success we are achieving.

I've even had one person say, "You could wear a bigger ring for important events, so people don't think you're not successful."

Wait a minute: Since when did the size of someone's ring become an indication of success?!

For me, the ring is *so* much more.

My ring symbolizes a whirlwind, storybook, "make you sick" love story. It reminds me of how my husband and I met and fell in love in one night at a Perkins diner.

He worked as a window washer, and I was a single mother.

One short week later, we professed our love to each other, with him leading the conversation.

We couldn't stop dreaming of our future, so excited to have a baby, buy a house, and fall asleep together every night.

We couldn't wait for the future. So we didn't.

Thirteen days after meeting, we eloped. I didn't even *think* about a ring until my husband surprised me before the ceremony. He drained his savings to gift me with a small token of his love.

I say "small" only because it pales in comparison with how big his love is, even now, after years of marriage.

That, my friends, is success to me. **—RACHEL PEDERSEN**

MY DAD'S favorite acronym is FAMILY: Forget About Me, I Love You. He quoted it all the time about how we choose to put others first to make our family successful.

He is now nearing stage VII Alzheimer's and the disease has progressed rapidly over the past two years. He no longer knows who I am or that I am his daughter.

Three years ago, when my youngest son, Alexander, was born, he headed to the neonatal intensive care unit, and I was hospitalized for a week with complications. My family instantly stepped up: my brother Mike walked through the hospital door ten minutes after I called him, whisked off our boys Thomas and J.P., and did all my admitting paperwork, since I'd been admitted immediately during my ob/gyn appointment. My sister-in-law kept the older boys for the next few days until my husband, Jonathan, knew that I would be okay. Meanwhile, my mom, who was ill at the time, kept everyone updated.

My dad came to visit me and then went up to Alexander in the NICU early every morning before the stock market opened at six thirty. "You know, sweetheart, I could call you to check on you," he said, "but I'd really rather see you and my grandson in person. I love you, honey."

Tonight my dad is sleeping in my home office, so I can give my mom a much-needed respite. Three-year-old Alexander and I tucked him into bed and gave him a kiss good night.

Wow, how times change.

Dad, I could call you to check on you, but my son and I would really rather see you in person. I love you, Daddy. **—SHELLEY MAUSS SPROUFFSKE**

MARIA KATIE ANDREWS: I think I might start living my life around your father's acronym. It is honestly one of the best quotes I've heard in my life so far.

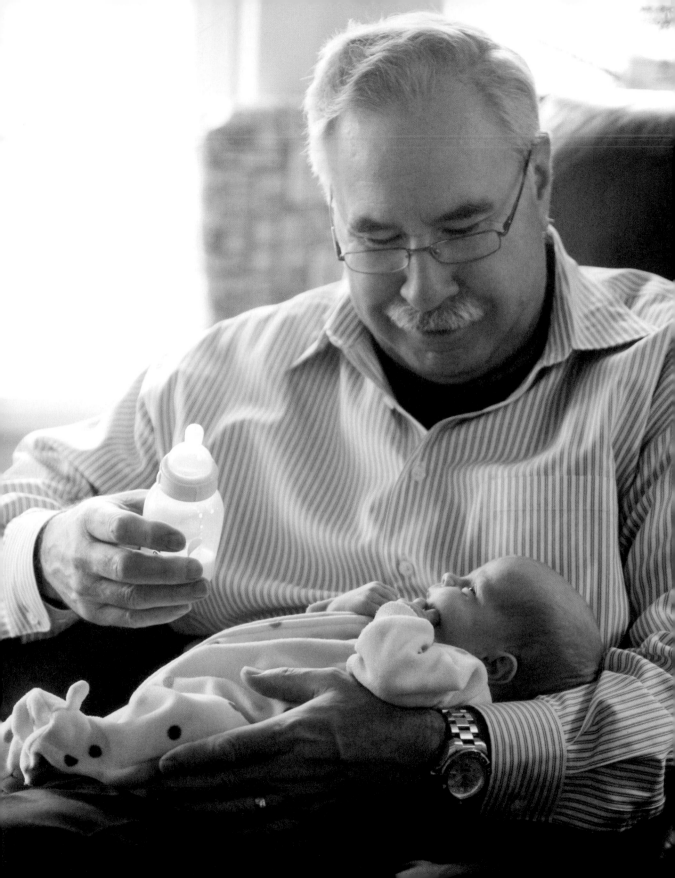

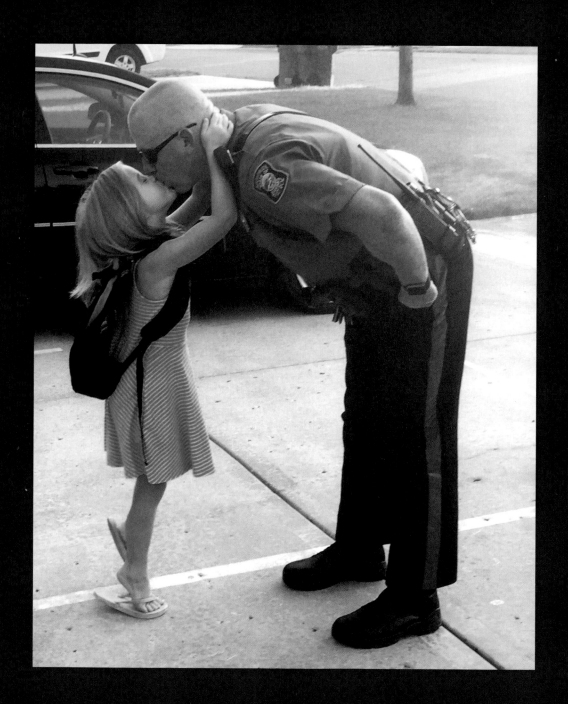

THIS is a picture of my husband and our youngest daughter. He is a state trooper for the state of Kansas. This picture was taken on his birthday and her first day of first grade. Thought I'd share a different side of police officers—one that we see every day. Love really is all that matters.

—**ERIN LOVEWELL**

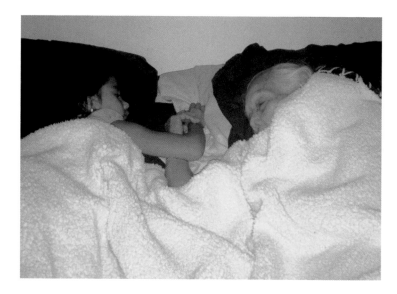

JUST arrived home from a business trip and went in to check in and say hi to my grandma in her room and found my baby girl and her asleep holding hands. The picture of love that spans four generations and the eighty-six years between them—love them.

I remember being about my daughter's age and making my grandma promise to live until I was forty. (As a child, forty feels forever away!) And in my twenties, going through a divorce, I remember my fears of not finding love again in time to have kids who would be able to meet this amazing woman. So blessed that my prayers were answered—but I've been praying now for many more years beyond forty.

—KRISTINE KINNINGER

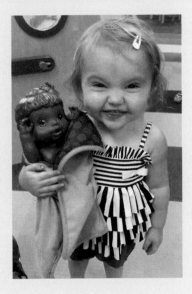

simply human

IF YOU have seen my daughter out, more than likely you have seen her with this doll. Six months later, this is still her "go-to" doll when we leave the house. She chose her because she was "pretty" (which is also her name). The current situation in today's world has brought her quite the attention when we're out—from random people, black and white, coming up to her and saying anything from "That is such a great sight to see!" to "I wish this world showed unity and love like she does to that doll." Her clueless two-year-old mind will usually just reply, "Her name is Pretty."

Ultimately, she is holding nothing more than a doll that happens to be black. But wouldn't it be awesome if we all looked at one another more as simply . . . human? **—TYLER VER VYNCK**

31

MY SIX-YEAR-OLD son, Grant, has

a large port-wine stain birthmark on his face. His birthmark has not bothered him that much over the years. However, in the last year, in kindergarten, it really has, and he's said he wishes he didn't have it. He isn't bothered by what it looks like; his pain comes from strangers constantly asking him what happened to his face or what's "wrong" with his face, and so on. He has his canned response—"It's just a birthmark"—which he used to say very matter-of-factly, but lately he's been saying it in an exhausted manner because he's just tired of having to explain it to everyone he comes in contact with, and people saying things that maybe they don't realize are incredibly hurtful. One time, at the doctor's office, after Grant told a medical tech it was a birthmark, the tech said, "Oh, I thought you got punched in the face!"

This past school year, during class, he got a bathroom pass and went to the bathroom. A kid he'd never met before was in there and, per usual, asked what happened to his face. Grant gave his usual response. But this kid did something different. He said, "Well, your birthmark is really cool." And then he asked Grant if he gets hurt feelings from people asking about

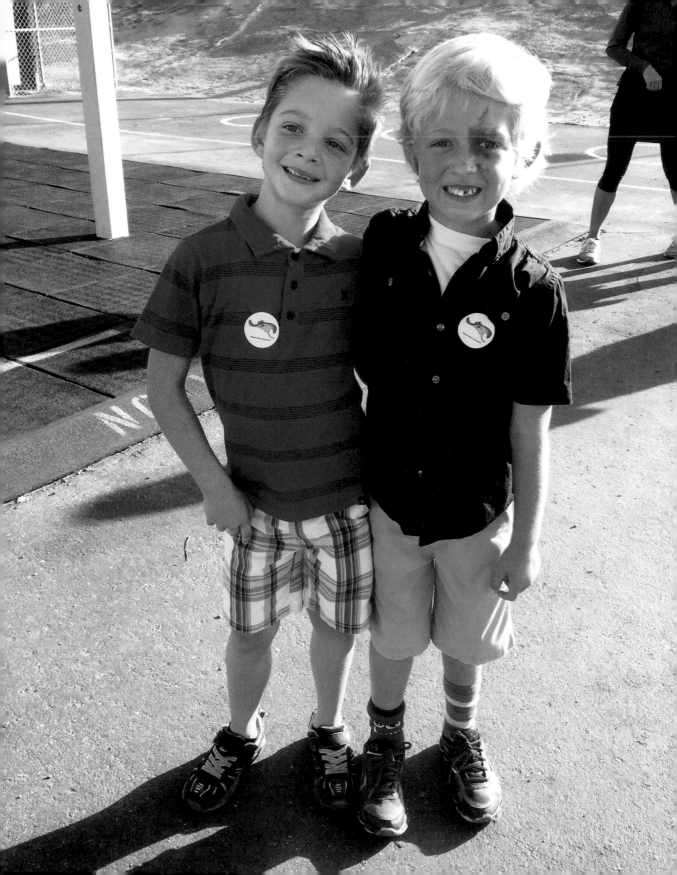

it or making fun of it. Grant said that, yes, he does. The kid then looked at him and said, "Stick up for yourself, kid."

And just like that, Grant felt supported and cared about, because this random stranger had something "nice" (his word) to say about his birthmark. This made Grant so happy. He had the biggest smile on his face telling me this story.

This kid he met has more kindness, empathy, and emotional intelligence than many people quadruple his age. With all the challenges in dealing with mean kids who hurt others' feelings, wow, does this kid give me hope.

I was determined to find this amazing kid (Grant didn't get his name or grade level), so that he and his parents could hear about his compassion and kindness. Frankly, I just wanted to give him a giant bear hug because I was bawling tears of joy for about three days after this happened. It took us several weeks to figure out who he was, and I reached out to his parents to share what had happened.

I thought for sure this kid had to be in fourth or fifth grade, based on his maturity and social confidence in reaching out to Grant. Well, was I really, really wrong. His name is Tucker, and he's in first grade. Yup, first grade. According to his teacher and his parents (who are amazing, by the way, and just as touched by this entire thing), he's "incredibly shy"—a gentle,

introverted, and reserved little boy. A boy who felt compelled to break his shyness to reach out to Grant because he too has experienced sad feelings when kids made cruel comments about him. A kid who told his parents he'd made a new kindergarten friend that he met in the bathroom, and described him as having "white hair"—not as "a kid with a birthmark." A kid who is in the before-school care program with Grant, whom Grant never noticed because Tucker is so shy. And now? Two boys, new friends, and play dates being coordinated.

Tucker is excited to have Grant over and splash in his pool. Grant is trying to negotiate meeting at a park, since he's scared of dogs, and Tucker has one. Regardless of where or when they get together, my heart is happy seeing these two boys together sharing a friendship that started with empathy, courage, and sincere kindness. Let the fun begin! **—MADELINE SCHMIDT**

JAMIE LYNN ALLEN: What a sweet story. Reminded me of a few years back when my daughter came home from school going on and on about a new friend she made. She described her in great detail: her personality, her freckles, her hair color. A couple weeks later, while I was at the school, we passed the little girl in the hallway. My daughter said, "This is my friend I was telling you about!" My heart nearly exploded with joy when I met the little girl and noticed she was in a wheelchair—because my daughter never once mentioned that about her.

35

I ADOPTED

my son at birth knowing he had a genetic disorder. He is now six and nonverbal but uses sign for communication. We are fostering a beautiful deafie boxer girl (soon to be adopted!). She is amazing with my son. She is the most gentle, loving girl ever. The most *beautiful* part of this adoption is that my son and his dog can actually talk to each other! I highly encourage adoption of deaf dogs. She is such a perfect addition to our family. We have been blessed with Ellie. **—BRANDI GUILLET**

MIRANDA SHARP: My daughter has Chiari malformation. Our rescue Pomeranian, Peanut, alerts us to when she is about to have an episode by lying across her head. Bless the hearts of these selfless animals.

NATASHA CORMIER AYMAMI:
Our deaf pup is the white one.
My parents are deaf, and I'm a
sign language interpreter. When
Marley was given up to a shelter
by her breeder because she was
deaf and considered worthless, I
knew we had to have her. She is
such a loving pup. Deaf pups are
so smart and adaptable. We will
always have a deaf pup.

THIS WOMAN, Kaylen, at Sports Clips in

South Charleston, West Virginia, did more for my
heart than she will probably ever realize. Haircuts with
Isaiah are no small feat. He hates having anything near
his ears, the sound of clippers sends him into a tailspin,
and this evening was no different. I was ready to give
up, but she wasn't. She sat on the floor with my baby
in her lap, and she cut his hair. They talked about Dory
and Christmas, and she even let him spray her with
her water bottle. Autism can be so very, very hard, but
people like this make our days just a little easier.

—JENNIFER McCAFFERTY

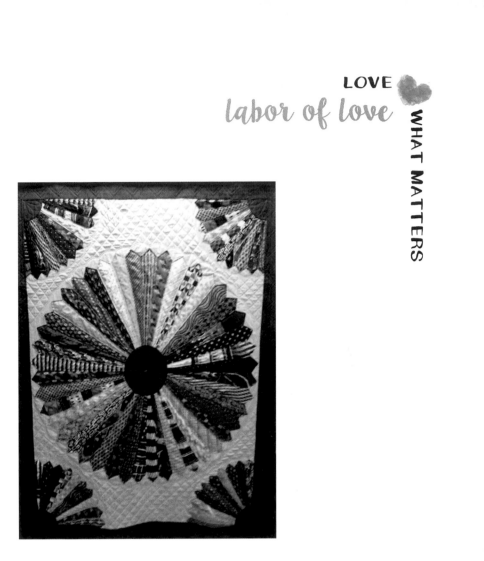

MY BELOVED husband of twenty-six

years, Drew, was called home after a nineteen-month battle with glioblastoma brain cancer. Shortly after, my dear friend Sue made this quilt for me and our daughters out of his neckties. This heartfelt gift was a labor of love that we will treasure forever. **—KAREN WALSH MOUNT**

ME: "Sweetie, I laid your clothes out last night for our Memorial Day weekend trip. I was so tired, though, I didn't pack your clothes, so I will do it today."

SIX-YEAR OLD: "Mommy, I knew you were tired, and you were getting sleep, so I packed my bag myself."

—RAQUEL RILEY THOMAS

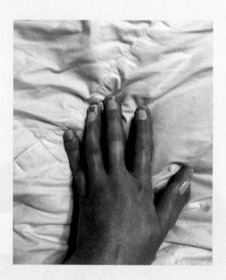 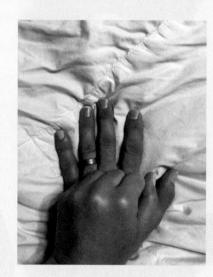

THIS IS WHO I MARRIED . . .

I was painting my nails and made a comment that I forget I don't have to paint my pinky nail on my left hand. I simply forget that I'd lost my pinky, but it is always kind of a bummer when I am reminded. Matt said, "I will be your surrogate pinky. You can paint my pinky to match your nails for the rest of our lives."

And so we did.

I cannot imagine a sweeter, kinder man. No words adequately describe our love. **—LIBBY SANDERS**

I GOT TO

witness a real-life PS-I-love-you story. These flowers were delivered to work today for a lady I work with. They are from her husband, who passed away two years ago. Every holiday and birthday since his passing, she has been receiving flowers, presents, and jewelry from him. Before he passed, he lined all of this up for her so she wouldn't feel alone on those days that would be the hardest to spend apart. I am sharing this story not only because it's amazing and it warms my heart but also to show girls that true love is real. You don't have to settle for someone because you think no one else will love you. You don't have to put up with being cheated on or lied to or being talked down to. You are a prize to be won, and there is someone out there who will love you forever and even through the afterlife.

I hope this brightens your day, and PS, I love you.

—KAYLA MILLER

you changed my life today

A STRANGER

paid for our groceries today. All $178.86 worth of baby food and deli meat and milk and veggies paid forward at check stand eleven. It was the most incredible generosity I've ever experienced in my life. After a day of PMS-ing and dealing with boys who love me so but just *don't* get it, I took a "break" at the market with just one kid—the one that doesn't talk back (yet).

After feeding him teething crackers to get through the trip, I placed all our items on the belt, handed the cashier our reusable bags, and turned around to a sudden panic while fumbling around my walletless diaper bag. Holding my forehead in despair with one hand, I called my husband with the other and pleaded for him to teleport my wallet to me in that moment, when I heard her behind me: "Keep ringing everything up; I'll take care of it." I whipped around in absolute disbelief and shook my head. I glanced at the screen at an unfinished subtotal of $70 and whipped around again, thankful, but insistent that it was just way too expensive.

"Seriously, don't worry about it," she told me, her insistence stronger than mine. "I need to do something for the holidays. Merry Christmas, enjoy!" I felt my eyes welling up with joyful, humbled, grateful tears. This is the stuff you read about that makes you smile, but when it's real life? *Your* reality? You changed my life today, ma'am. This moment is now forever ingrained in my heart, and every Thanksgiving I'm bringing *your* love to my table. Thank you, from the peaks to the depths of my heart. Thank you. **—DANIELLE VINSON**

WHAT MATTERS

a better understanding

LOVE

I JUST can't shake this sad feeling I have had since my husband told me this story today. I wasn't going to share it but then decided that if it could enlighten one person, it would be worth it. My husband, Dustin, was at work yesterday, sitting at a big lunch table of about fifteen people. These are all guys whom he waves hello to but doesn't really know on a personal level.

Anyway, one of the guys starts telling the whole group a story about a Halloween party that he attended this past weekend. The guy says, "Oh my God, my brother came to the party and had the best costume: he went as a *retard*! Oh man, it was hilarious! He was awesome. He looked like such a good retard!"

My husband was totally taken aback and just sat there pretty stunned for a moment while he gathered his thoughts. Meanwhile, some of the guys were laughing at the story, while some were just listening. So Dustin, almost giving the impression that he was going along with it, said with a small smile, "Well, wait: What does a retard look like?" The guy just said, "I don't know, but he was good! He was the perfect retard."

A couple seconds went by while Dustin took out his phone and pulled up this picture of our daughter and then pushed his phone to the center of the table. He said, "This is my little girl, Raegan," and all the guys, including the storyteller, leaned in to look, and

48

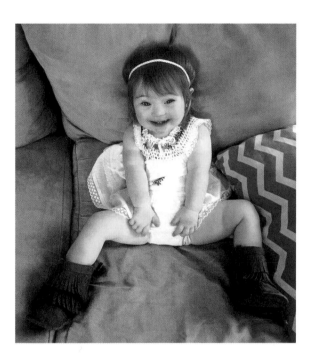

they all started saying, "Awww, she's adorable!" "Wow, cute kid, man!"

Dustin then looked at the storyteller and said, "Thanks. She is amazing. She has Down syndrome. So I'm sure you can imagine that I don't appreciate this costume conversation. I'm just wondering, is she what a retard looks like to you?" Of course, mouths dropped, and there was total silence while the guy tried to say that wasn't what he meant, and on and on. My husband just went on to explain why that word is so hurtful, shouldn't be used, and especially how insulting it was to use it as a joke and a costume.

Yeah, I'm sure it was pretty uncomfortable for everyone involved. But I think that those people at the lunch table probably went home with a little better understanding of why that word is so offensive and hurtful, especially to a family like ours. And I think one guy in particular probably went home feeling like a total jerk. At least some good came out of it, but it still makes me feel so sad that some people look at our kids as a joke. I've said it a thousand times: there are so many words in the dictionary that you can use in place of the "R" word. Please, for Raegan's sake, consider using a different one. **—SHANNON DAUGHTRY**

DEBBIE MOSIER BERLINGUETTE: Here's a photo of my awesome big brother (demonstrating his new Spider-Man shirt, ❤)! So well said, Shannon. The R word is disgusting. For anyone not having the opportunity to love a person with DS, it is such a loss for them! Can't imagine my/our life without Dougie and the gifts of love, joy, celebration, and enthusiasm that he teaches us!

AISHA HERRELL: I remember all of the nurses telling me that my son didn't look like he had Down syndrome, but I knew in my heart that he did, and I accepted it. He was beautiful to me no matter what he looked like.

50

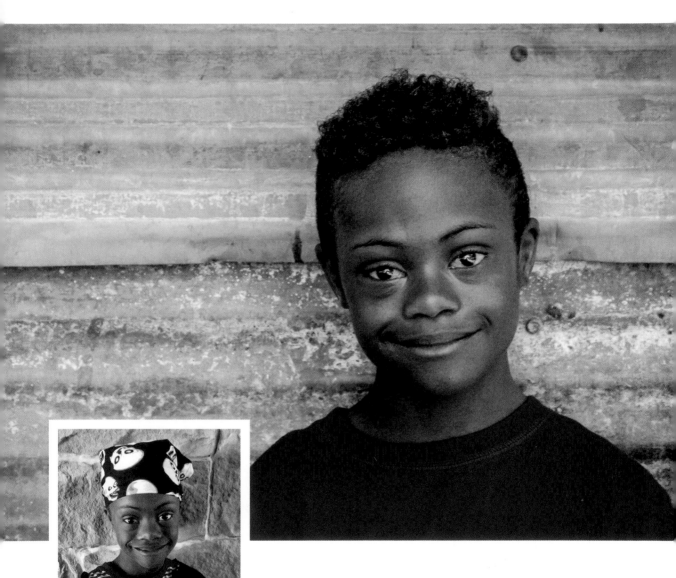

ASHLEE BECK: Here's my son as a pirate. Your daughter is beautiful. Great story. Some people truly do not know that it hurts other people's feelings to say that word. I'm glad that he could educate them in love and not just haul off and smack them or scream at them. And now maybe next time they hear that word, they'll tell this story. Be blessed.

51

Server: Deric DOB: 03/05/2016
09:35 PM 03/05/2016
Table 18/1 1/10034

 SALE

Visa 3145757
Card #XXXXXXXXXXXX3146
Magnetic card present: Yes
Card Entry Method: S

Approval: 005

KARMA!!!

 Amount: $ 49.92

 + Gratuity: _____ 50.08

 = Total: _____ 100.00

random act of kindness

A COUPLE of days ago, I was standing in line at the bank.

A young girl, of college age, was behind me with a Mason jar one-third filled with coins. I commented to her that she was supposed to wait until it was completely filled before cashing it in. She said that she didn't have any money in her account and had to cash it in now. It totaled probably $5.

I remembered being a poor college student myself thirty years ago at Brigham Young University. So when I got up to the teller, I told her to withdraw $50 from my account and see to it that the $50 was deposited into the account of the girl on line holding a jar of coins. The teller asked me, "Why? Do you know her?" I replied that I did not, but it seemed to me she needed the money more than I did, and I was just paying it forward. The teller told me that was one of the nicest things she had ever seen. I left feeling good. And I secretly asked my Heavenly Father to bless both the young lady and me—because I have bills too.

Tonight, at the end of my workweek waitressing, my last customer was the answer to my silent prayer. The dinner check came to only $49, I was tipped $50—the same amount that I had given to the young lady earlier that week! They tipped me not the usual 18 percent to 20 percent but a full 100 percent! Someone paid it forward back to me! Karma! I felt blessed! Remember, paying it forward will eventually come back to you! **—DERIC WORTHAM**

EVERY MORNING, I walk into our closet and see these: my husband's police uniforms. Not many have these hanging next to their jeans and dress shirts. He didn't choose to wear these for the fame and fortune. He drives his old, hail-dented, hubcap-less, duct-taped Mitsubishi to the police station every day so I can drive "his" newer truck. He hates coffee and writing tickets. He avoids donuts and cussing. There is no typical day at work. His office is his police car, his computer inside it. Some days he comforts victims of sexual assault or rape. Some days he gets in high-speed chases to catch a guy who shot a girl, nine months pregnant, in the stomach, killing her. Some days he convinces suicidal persons to keep on living. Some days he enters the stench of trash-filled, bug-infested, drug-dealer apartments to see five kids under the age of six running around. Some days he gets fire ant bites from diving into flash-flood waters to save a family of four submerged in their vehicle. Some days he jumps fences in foot chases. Some days he responds to domestic disputes, never sure if he might meet a gun to his face at the door.

And some days he rides his police bike and enjoys the random acts of kindness shown to him and his police friends. He loves the kind words and lunches paid for by random strangers in restaurants. He always tells me about them. He has a daughter who adores him and two sons who are so proud of him. He's called Poppa and Pa Jason by his two grandchildren. He loves his giant dog, Nala.

Sometimes I get mad at his clothes draped over the tub and his tote bag lying on the bathroom floor with his police gun inside. Long ago, when he worked deep nights, I would be awakened to the loud sound of Velcro being detached as he removed his bulletproof vest, and I'd be annoyed. Today I'm praying for those families not much unlike mine who wish they could hear that Velcro sound again. **—BETSY GIRON**

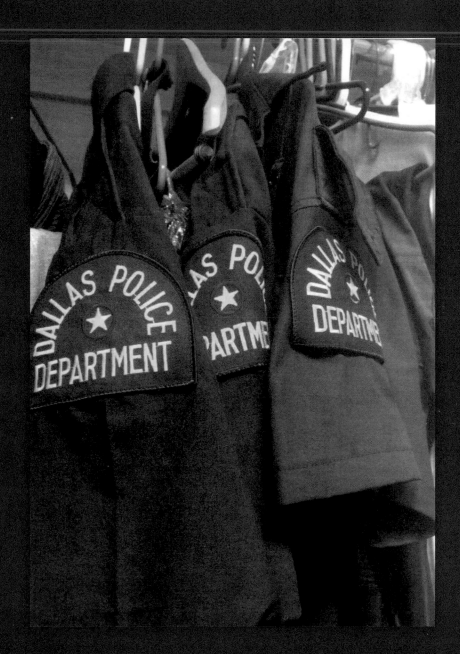

♥ *the strength of their love*

THESE are my parents' hands. My dad had cancer, and my mom had Alzheimer's. I'd taken him to the hospital for a procedure, and while we were waiting for him to go in, my mum—who couldn't remember where we were—gave me a priceless memory. She managed to scoot her wheelchair over to my dad and reached for his hand. I quickly and quietly captured the moment. She may not have known why we were there or where we were, but her heart remembered, and their hands show the strength of their love. **—LYNNE BUDNIK**

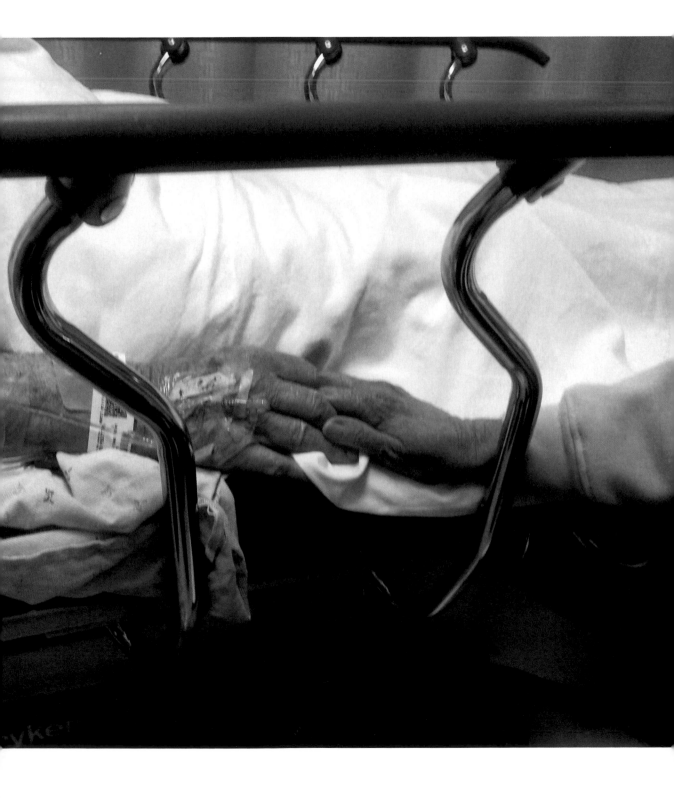

LOVE

father of the year

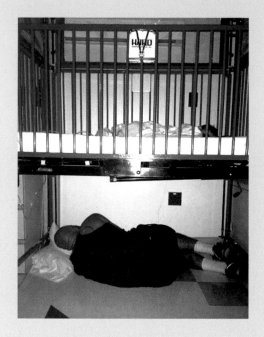

THIS is a picture of a hardworking man dedicated to his family! After working all night, third shift, he's right here with his son, who is in the hospital. He's so tired, but he's here! Father of the year award goes to Andre Palmer! I love you more than words, baby. **—AMY PALMER**

KEVIN BURGESS: There are countless moms, dads, aunts, uncles, grandparents, and even friends out there who do this every night of the year. My little boy battled neuroblastoma, a form of childhood cancer, for nearly two years before passing away, and not a night went by, when he was in the hospital, that either his mom or I wasn't there with him. This is love, and this is what love does. Every single day in the United States, nearly fifty children are diagnosed with a form of childhood cancer, and with every child comes another parent, grandparent, aunt, uncle, or even family friend who will spend countless nights curled up on whatever they can find, so their precious child isn't left alone.

with love and pride

THIS is my four-year-old daughter, Charlie, at her T-ball game. She didn't expect her daddy to be at her game today, as he had been out in the field training for the last two days. She was elated when she spotted him making his way out to her on first base.

She doesn't realize it, as she's been a "military brat" all her life, but her daddy misses out on a lot of these special moments. To her, this life is normal; this is all she knows. Military children sacrifice so much, yet they beam with love and pride when they see their soldier mom or dad. Making those sacrifices pales in comparison with these moments. It doesn't matter how many days, weeks, or months her daddy has to leave for work. When he returns, it's as if they never missed a beat. These kids spend their adolescence sharing one or both of their parents with the military, moving across the country (or around the world) every few years, changing schools, leaving friends, leaving behind memories and everything that is familiar to them— their home—as they move on to a new duty station, meet new friends, find a new school, and make a new home. Yet they adapt and overcome these changes better than most adults. I'm overwhelmed with pride to have not only such a selfless husband but also such resilient kids. These moments put everything into perspective. **—MICHELLE RANDALL**

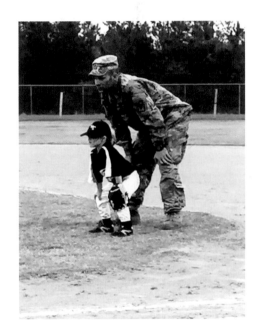

a welcome delay

TODAY I purposely delayed my flight, and I will always fly American Airlines from now on. Here is why:

While on the phone getting ready to go find my gate, I noticed a man (his name is Will K.) lying on the floor in distress. It was clear something was wrong, I just didn't know what. After asking him a few questions, it seemed best to call for medical assistance. He told me several times that he was afraid he would miss his flight while waiting for the airport medical team, and I realized that he was most likely autistic. That triggered me to switch gears. After assuring Will about his flight time, we called his mom to let her know he wasn't feeling well and would be seeing the medical team at the Dallas airport. After much back and forth with the airport medical team, his mom (who confirmed he was autistic), and American Airlines, the medics said he needed to eat and have something to drink; they were worried he would get sick again and didn't know if he should fly. I told the medical team I would change my flight, grab some lunch with him, and make sure he got on his flight. American didn't charge me a dime for the flight change and even called me while Will and I were eating lunch together to let me know that his gate number had changed.

When I dropped him off at his gate for his flight, the American Airlines team took great care of him, checked on him, and made sure he boarded safely to go see his mom for Christmas. Today was not at all what I pictured it to be. It has turned out so much better. American Airlines handled the situation with such professionalism and care. The medical team at Dallas as well as the police were also just as amazing. Every once in a while we all need a little help, regardless of disability, age, or social status. Thanks for making my day, Will! —**SHAINA MURRY**

THIS is my math professor Dr. Josie Ryan with my son. She's amazing. She knows I worked and continued school while pregnant this past semester. I started her class the week before I had my son in August and started attending her class again the week after I had him. She knew I'd be overwhelmed, so she literally begged me to bring Isaiah to class and even showed me to the breastfeeding room in the health center.

It's so reassuring to know there are professors out there like this. Not only is she an amazing person, she's also one of the best math professors I've ever had. She's brilliant, wacky, and the best kind of nerdy—the kind I can relate to, LOL. But hey! Maybe the world needs more of these teachers! Hopefully this post will encourage other moms or pregnant/working women who are students to ask for help.

She's encouraged me constantly. I've brought Isaiah to our Real Analysis class multiple times now.

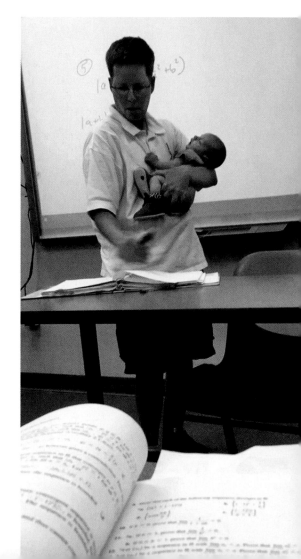

62

He'll cut the cheese and make the class giggle from time to time, but we still get down to some serious math in there. I am in a perfect world when I am learning math in college with my baby right next to me or in my teacher's arms. She taught like this: holding him the whole first class I brought him to. —**SARAH THOMPSON**

MICHAELANN ALLEN: I let my students bring their kids as long as it's not a clinical class, and there are no safety issues for the kids. I remember being a single parent and working three jobs while attending school. Day care isn't cheap and not always reliable.

JAMIE HATFIELD: What the world now knows about Josie Ryan:
- She is an educational advocate for her students.
- She helps students achieve inside and outside the classroom.
- She is a caring and generous person.
- She loves holding babies.

What *I* know about Josie Ryan:
- She is the most generous friend, sister, and daughter.
- Her brilliance in mathematics is eclipsed only by her devotion to teaching others to love it too.
- She cares deeply about the people God puts in her path to care for, and takes that responsibility as a sacred trust.
- She doesn't realize the expanse of her impact and the depth of gratitude people have for her, nor the fact that this story shows only a glimpse into how valuable she is.
- She loves LEGOs, Harry Potter, and all things *Star Trek*.
- She knows girls should have all of the choices to pursue the same interests and be given all of the tools and opportunities as boys, and that pink toys and "girl versions" of toys are idiotic.
- She knows what friendship really means and has been teaching that to me for twenty-four years.
- She is my best friend, and I am so proud of her.

MEET MR. TIMMY, the angel who walked into my

chiropractic office. He stopped in a week ago asking if I could help him with extreme low back pain that was shooting down his leg. He asked the prices and so on, and made his appointment for this week so he could gather the money.

He came in on Wednesday thirty minutes early for his appointment and was beyond nice and respectful. Everything I said and asked him, he responded with "Yes, ma'am," "No, ma'am." He filled my heart with joy and happiness just being in the room with him. Mr. Timmy told me that he's been in pain for three years and has been turned away for medical care several times because he doesn't have insurance or the money, but he knew he had to do something. I could tell he was hurting but didn't know just how bad until I asked him to lie on the padded chiropractic table. Bless his heart, tears started streaming down his face, and he was moaning in excruciating pain. He apologized for his tears, and I told him not to be sorry and handed him a tissue. I started adjusting him, and at first he moaned with each drop of the table (bawling his eyes out now), but said to keep going if it would help. Then it started feeling better for him. I hooked him up to the electrical stimulation machine and told him to enjoy some relaxation.

When I came back, Mr. Timmy said, "Oh my goodness! This is the best I've felt in three years. Thank you, thank you, thank you!" He stood up and realized he could stand up *straight* for the first time in three years. *Three years!* Those tears of pain turned to tears of relief and gratefulness. Then tears start rolling down my face too—tears I'd been holding back the entire appointment.

He asked when I wanted to see him again, and I walked him up front. I told him I wanted to see him the next day, and he asked how much it would cost, because he'd need to find a way to get the money, but he'd

pay me in hugs

be here. I gave him back his money and said, "Nothing." He looked so confused. (He'd told us he eats only once a day.) He lost it again, and I gave him a big hug while also crying. He told me I didn't know what this meant to him and that he'd find a way to pay me. I replied, "Please don't worry about it. Just pay me in hugs."

He was in pure disbelief. My staff and I were all crying; we all felt this God moment. Mr. Timmy came back today with a huge smile on his face and a little kick in his step. He was so happy; he was on the road to recovery. His smile lit up my whole heart. We had gathered a box of snacks, a gift card for the subway, and a card. When we gave it to him, he started crying again and just kept thanking us over and over. He gave me several hugs and couldn't believe the love we showed him after his having been dismissed elsewhere so many times. I've been thinking about him and praying for him nonstop since then.

With tears in my eyes while typing this, I share this story with you to say this: you never know what form an angel may come in, but I promise you that Mr. Timmy is an angel to me. You never know what someone is going through until you ask. You never know what a difference you may make in someone's life, but I can tell you that Mr. Timmy blessed me far more than I blessed him. With all the evil in the world, there is still good—all you have to do is open your heart and share the love.

—JESSICA BULLOCK SCARRATT

ANDREA SWENSEN FERRY: Love this story. Years ago, I too met a wonderful doctor. We were pregnant with our third child when my husband found out that he was going to be losing his job. (As it turned out, he lost it the very day that our baby was born.) Of course, I was upset and shared this with the receptionist and the nurse. When the doctor came in to examine me, he took my hand and told me that my job was just to have a healthy baby and that no payment would be due. We could pay him after my husband found another job and had worked there for a year. I will never forget the kindness of that doctor. There are angels in this world, and I have found some. :)

CHOPPED CELERY. That's what I'm

driving to my son's school today. Why? Because I don't
look in his folder. I missed that he needed to bring
chopped celery to school today, and I have no idea
why he needs it, but he does. So I'm driving it to him
praying that he gets it on time.

I miss things.

My kids don't always have clean socks.

We ate at Wendy's last night.

I forget to RSVP to parties.

We never have cash when we need it.

My kid doesn't always have his coat.

There might be Halloween candy in their lunches.

I sign things without reading them sometimes.

And I don't always check my kids' folders.

But I love them. And I work dang hard for them.
And I'm banking on the fact that twenty years from
now, they won't remember that their mom forgot the
chopped celery. I am praying they remember how hard
I fought for them every day to have a good life—one
where they know they are loved fiercely no matter what.

—KARA LEWIS NEWTON

PAULA MENZIES: I was the world's worst
tooth fairy. The tooth always sat under the
pillow for two nights. Luckily, my kids still
think I am awesome, and they laugh about
it now. That makes me thankful.

KITCHEN CHECK

Date	Table	Guests	Server	76431

APPT–SOUP/SAL–ENTREE–VEG/POT–DESSERT–BEV

I lost my wife to cancer 5 yrs ago. I know how tough it can be going thru this. Your meal is on me.

Merry Christmas

LAST NIGHT, after church, we went out to eat at a little Chinese place. Right as we were getting ready to ask for our bill, the waitress brought us this. More than anything, having cancer has shown me that there are a lot of good people in this world and that I am grateful my own family won't be leaving notes like this for others. It has been hard, I have fought, I have been sick, tears have been shed, I have missed out on things, I have lost my hair, and I will lose my breasts, but I will live. *I will live.* My parents will still have their daughter, my husband will still have his wife, my children will still have their mother. Whoever you are: thank you.

—JERINA EDWARDS

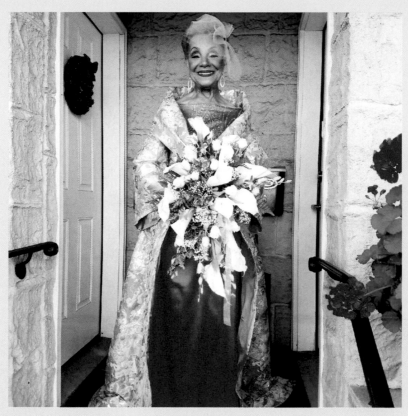

THIS is my beautiful grandmother, Millie Taylor-Morrison, who was married over the weekend one week after having turned eighty-six. Her new husband will be eighty-six in December. My grandmother was married to my grandfather for forty-one years when he passed away. She found love again almost twenty-five years later, and our family couldn't be happier for her. This is a true testament that age is just a number, and everyone can find love again. **—KHADIJA ELKHARBIBI**

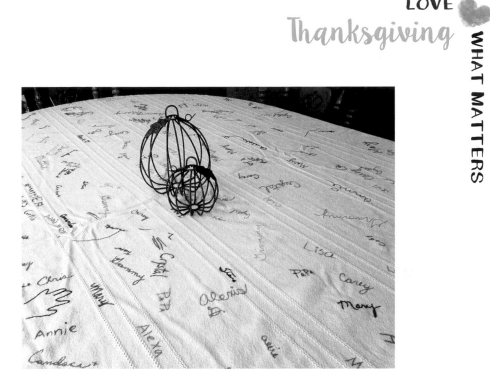

WE STARTED this tablecloth in 2000. It has the names of everyone

we've shared Thanksgiving with each year. Each year is a different color.
I am so grateful to have the signatures of those who have left us: Mom,
David's dad, our daughter Mary. It has scribbles and special messages.
Everyone signs it at our Thanksgiving, and then I embroider it each year,
and it is quite a treasure to me. Along the edge is a key of what color goes
with what year. Thanksgiving is this weekend at our house, so we are ready
for a new set of signatures. —DEB MILLS

♥ **LESLIE WENZEL VANHART:** We do this each
year in permanent marker and write what
we are thankful for. We started it years ago,
when my brother was very sick with brain
cancer, and we thought each holiday would
be his last. He's still here, married with three
little girls. To God be the glory.

DECEMBER 23, 2015.

I went in for an ultrasound, and what we thought was going to be a day filled with happy tears and laughter—that day did not turn out as planned.

I was at twelve weeks gestation when we were told something was wrong with my baby's heart. I was told she will not survive. "You will miscarry." I left the office in tears and heartbroken. My baby fought her way to eighteen weeks as her heart beat slower and slower. With each new appointment seemed to come another diagnosis, another heartbreak, and a waterfall of tears.

I was told, "She's going to be stillborn. Save yourself the pain."

"I wouldn't be surprised if you come back next week and have her stillborn." There was little to no hope for my baby.

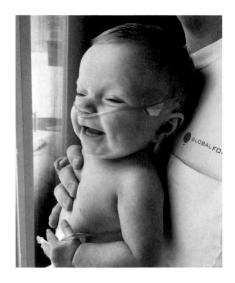

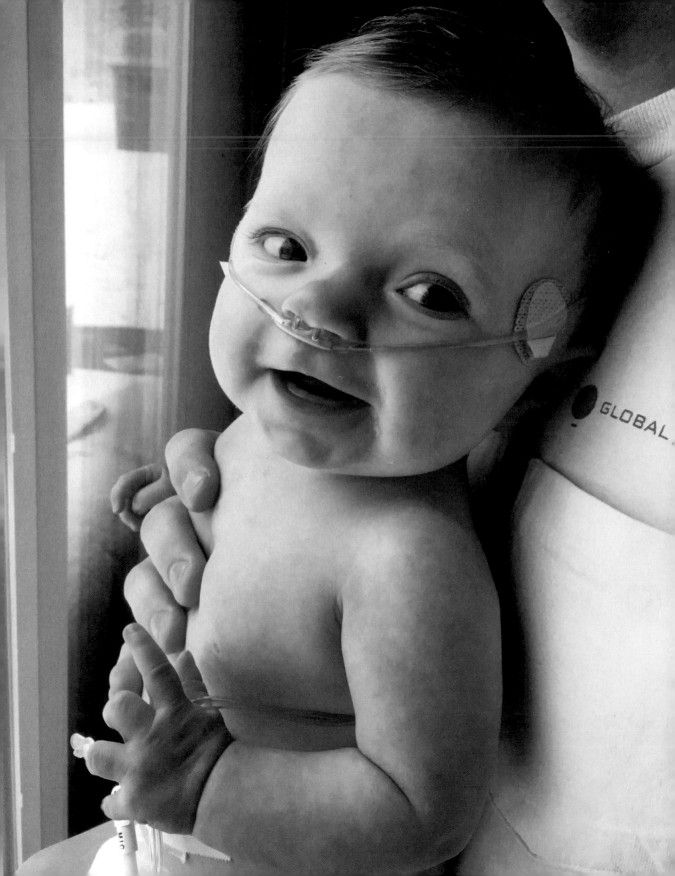

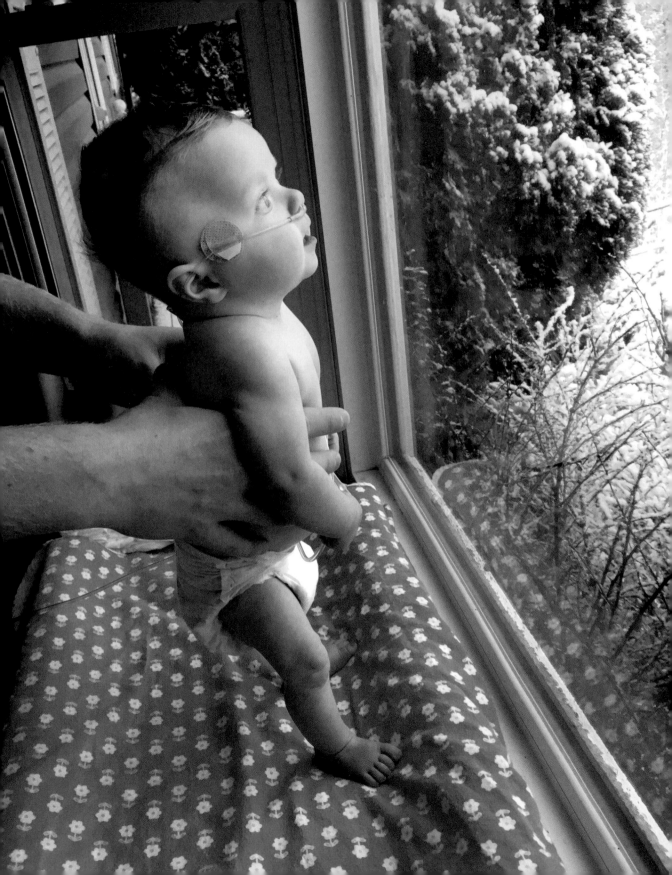

Even the number one children's hospital had not seen a heart like hers. They have seen it separate, but not all together.

It was up to her to fight. The only thing we could do was pray.

We continued to celebrate our baby's life, no matter what odds were against her. We had a reveal party, a baby shower, and even made a beautiful nursery.

In and out of heart failure, a heart rate of 40 to 50. Our baby girl fought her way to thirty-seven weeks!

On June 14 I had her via C-section, and she was taken straight to Boston Children's Hospital.

Six days old, she had her first open-heart surgery. July 21 we got to bring her home!

Five hospital stays since then and a couple more diagnoses—but she is a fighter! Her name is Clara Ray.

She is a Miracle.

This is her seeing her first snowfall. She absolutely loved it.

I can't explain the emotions we felt as we watched that smile come across her face.

Pure. Joy.

—JOHANNA MORTON

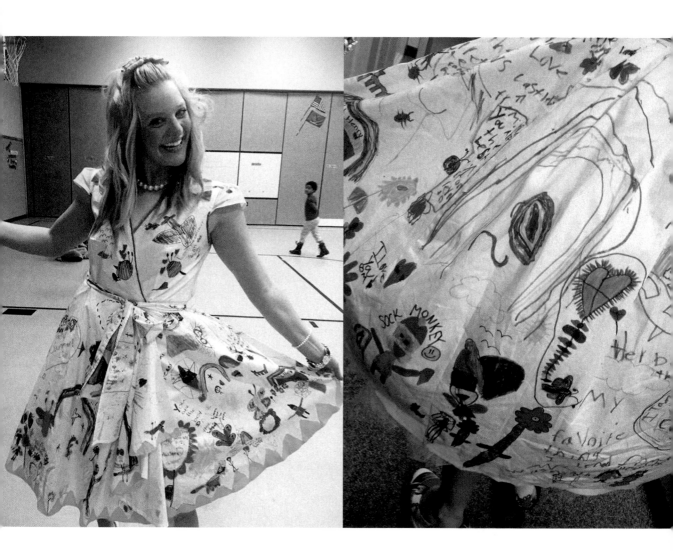

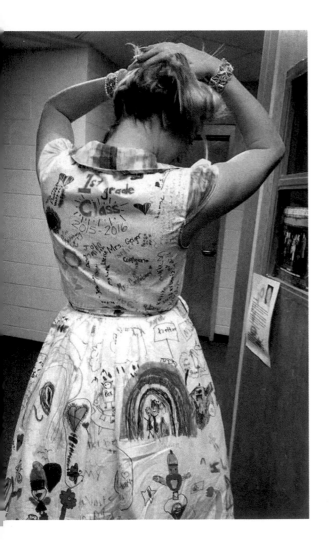

precious Picassos

MY FIRST original idea! This is
all artwork courtesy of *my* first-grade
class! Who am I wearing? Room 219.
Happy last day of school with my
precious Picassos!

—SHA-REE' CASTLEBURY

AHH!

I've wanted to do a taco smash *forever*! Luckily for me, Miss Stella's first birthday party was fiesta themed, and Mom was all about the taco smash! Way better than a cake smash, if you ask me.

—LYNDSEY WRIGHT

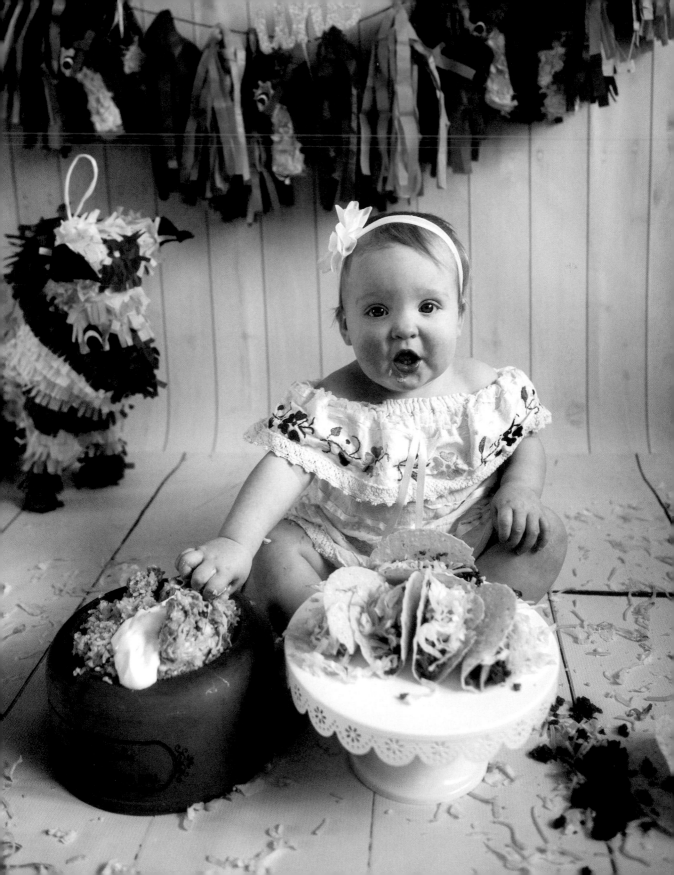

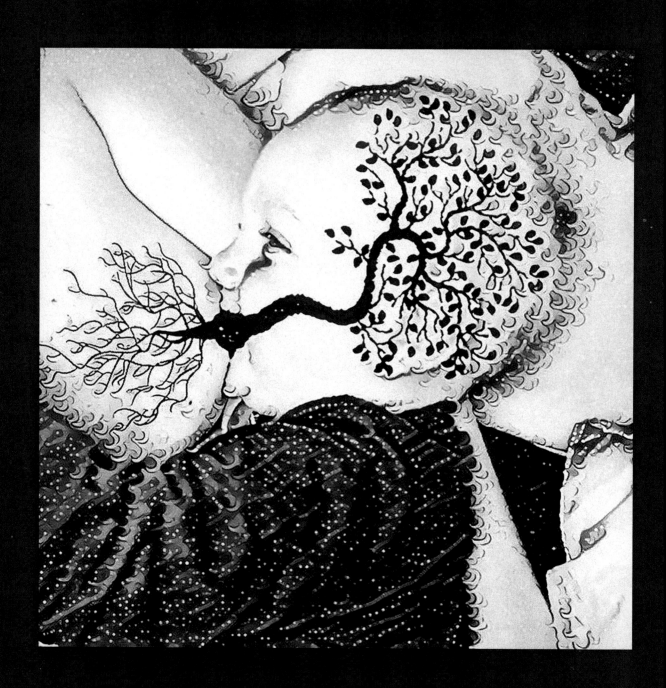

MY BABY

was born with no heartbeat. No oxygen to the brain. No pulse. He was revived after eleven long minutes. He was diagnosed with severe brain damage. I remember it like it was yesterday, being told that my son would have no quality of life. Being told to just "pull the plug."

I remember sitting in the hospital praying, hoping, crying. I remember wanting to fix him. I remember feeling so useless. My body had failed my son. I felt broken. As I sat next to his bed, trying to figure out what I could do to help him, I finally realized there *was* something I could do. As his mother, I knew I could provide the very most important thing that no one else could offer: *my milk!*

I didn't nurse my oldest son, Urijah, for more than three months. So with Ezrah, I knew this was what I needed to do, without question, no matter how hard it got. He was fighting for his life, and this was the only way I could truly give him my all!

I didn't know if my milk would do much for his injury, but I had so much faith that it would. I had no idea how quickly I would learn the power of mother's milk. It is simply pure *magic*! And now, fourteen months later, I know my milk has played a part in healing my child's brain injury. I *know* it. Women's bodies are *so* incredible. The way we are so connected to our children. The way our bodies know exactly what to do during childbirth. The way we heal. And then we choose to do it all over again! It's incredibly beautiful.

This picture shows *my milk* healing his little brain. I've had seven miscarriages, and this baby is my miracle, along with my three-year-old. This picture will forever be so close to my heart.

—TRISHA BELL

TODAY my patience had run thin, and all I could think about was having a few minutes to myself. But as you fell fast asleep on my chest, it was an easy choice, despite a list of things needing to be done.

Because instead, I held you.

I was going to get the dishwasher unloaded and the overflowing pile in the sink washed.

But instead, I held you.

I was going to get the clothes folded that have been sitting in the dryer, refluffed one too many times. And I was going to rewash the laundry that sat wet overnight.

But instead, I held you.

I was going to grab my two-minute shower, and, if I was lucky, I was going to blow-dry my hair and maybe throw on a little makeup.

But instead, I held you.

I was going to answer some work emails and respond to a few missed calls over the past seventy-two hours.

But instead, I held you.

I was going to vacuum up the crunched Mini-Wheats that you accidentally spread through the living room and stairwell, and clean up some of the toys that are strewn in every room but the playroom.

But instead, I held you.

I was going to get dinner in the Crock-Pot and go through the pile of mail that has been sitting on the countertop since Monday.

But instead, I held you.

I was going to carry you upstairs and lay you down, as I was pretty certain you wouldn't wake up if I did. Maybe you would have been more comfortable in your bed?

But instead, I held you.

You see, your little legs are already bunched up on the chair; it seems like it was just yesterday that your tiny toes were still resting upon my stomach.

Your tiny breaths and sweet hands fall so perfectly around me, yet soon you will prefer to stretch out in your own toddler bed.

It turns out that my plans for this time weren't going to accomplish what I have right here in my arms. I found my calm and peace and satisfaction right here, right now, because of one simple choice:

Instead, I held you. **—REGAN LONG**

JUST wanted to share this really sweet moment I had this morning.

Today was the first time I went out for breakfast alone with my eight-week-old son. I had just received my breakfast and hot chocolate when Jaxon started crying—wanting his booby—so, of course, I fed him. After a few minutes, this older lady walked up to me. I was scared, thinking she was gonna tell me to put my boob away. Instead, she started cutting up my breakfast for me and said, "What a good mama you are! We can't have your food getting cold, can we?"

I honestly could have cried loveliest lady *ever*!

—**BRIAR LUSIA McQUEEN**

♥ **STACI SEVIGNY FORTUNATO:** We took our six-week-old with his older brother to Red Robin. As soon as the food arrived, the baby wanted to eat. The wait staff brought me a fresh, hot burger and fries after he was finished eating, no charge!

♥ **KATIE GEE:** This is why I always buy expecting moms a pizza cutter—you can cut just about anything with one hand!

♥ **RENEE PALMER:** I was once at a coffeehouse with my then four-year-old son and six-week-old daughter when her cries pulled me away from the food I had just ordered. I covered up and settled in to nurse her, and a patron began to complain quite loudly.

A lovely family of four got up, walked over, and as the dad talked to the patron who was complaining, the mom sat next to me and chatted like we were old friends while her two kids played cars with my son. The owner also came out and apologized, gave me a gift card, and an invitation to come back any time—and politely asked the other patron to leave, as he was disrupting other patrons. I still to this day remember those acts of simple kindness.

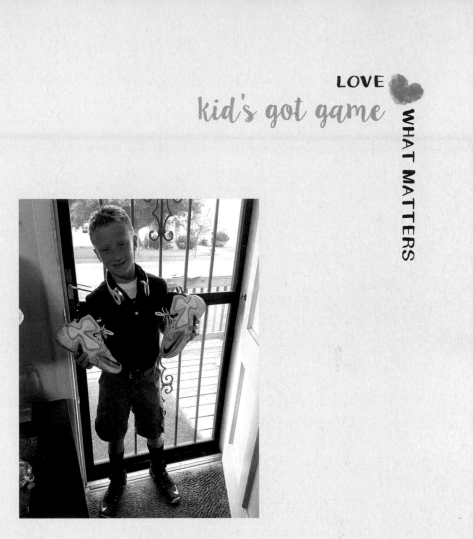

TODAY
Jaymes asked me if he could give a pair of his LeBron 13 basketball sneakers to a friend at school because his friend's soles were falling off. He said, "Why should I have all these nice shoes and my friend has to glue the bottoms on his?" I'm beyond proud of the heart this kid has.

—ERIN FEDELE

85

IT'S so interesting how seeing things through a child's eyes can open your own. For the past month or so, every time we pass someone asking for money on the street corners (which, sadly, seems more and more common here these days), Cole asks me if we can help them. I usually reply uncomfortably that we donate to the community in other ways. He replies each time with "Yeah, Mom, but why can't we help him? He's asking us for help."

It's been weighing on me—like the can't-sleep-at-night kind of weighing on me. He's right: Why can't we? And what kind of lesson am I teaching him? I love that he cares so much. I want him to know that there are things he can do, even at five years old.

So today we took a trip to the store with some ideas. Cole helped pick out socks and snacks and toiletries. We came home, and he organized and stuffed care packages. He is so excited about these that I honestly thought he was going to ask me to get in the car so that we could start handing them out right away!

This little boy has such a big heart. He managed to open my eyes and push my boundaries, and I am so, so very proud of him. **—KRISTIN CHARTER**

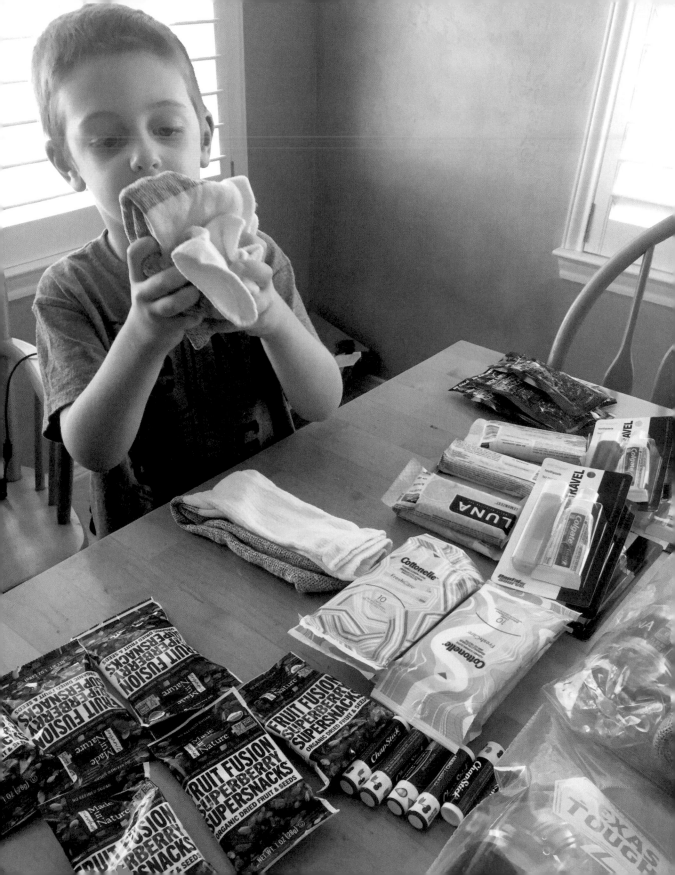

WELL, I know a lot of you guys are probably thinking, "Why would she post this picture?" But it took me eighteen months to get here, eighteen months to not cry when I look in the mirror, eighteen months to finally feel beautiful in my own skin again! No one warns you about the dark sides of motherhood and pregnancy. No one gives you a heads-up on how much you change physically and mentally after you become a mother. It's been a long and hard postpartum ride for me. Eighteen months after my first son and five months after my second son, I feel like I can finally see the light, and it genuinely feels amazing. Cheers to you mamas who are battling postpartum depression and still getting up every day for your children! Cheers to you mamas who still cry about the marks on your skin from birthing your perfect babies! Cheers to motherhood, cheers to knowing that this too shall pass! And things will get better. **—ALEXANDRA KILMURRAY**

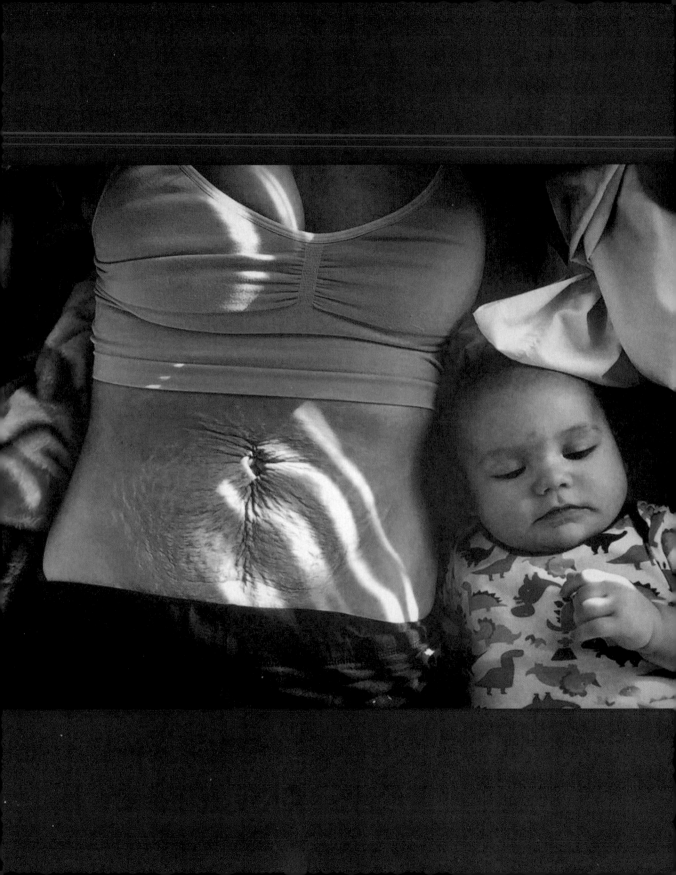

HE CAME INTO the café one day asking me for some

money. I looked at him and asked him, "Why don't you have a job? You know nothing is given to me for free, right?" He said, "Well, I have a lot of felonies, and no one wants to hire me for that, so now I had to turn myself to the streets and get money the only way I know: stealing and asking for money." I was short-staffed that day. So I asked him, "You want to work? I have a job for you!" His eyes opened wide, and his smile made my day! He said, "I'll do anything for some food."

So now, for almost two weeks, he has been on time for his two-hour shift helping take out trash, wash dishes, and so on. Do something nice for someone today and don't judge them just because they are out there asking for money, for we don't know their situation. Some deserve another shot. God gave me this blessing, so why can't I bless others? We want change? Well, start by making one. **—CESIA BAIRES**

teach your children well

I TEACH my son to cook and do household chores. Why? Because household work isn't just for women. Because one day he might be a single man, living on his own, who will actually know how to do laundry and not eat takeout every night. Because one day he might want to impress a significant other with a meal cooked by his own hands. Because one day when he has kids and a spouse, he's going to need to do his fair share around the home. Because I'm from a generation of people who complain that school didn't teach us how to cook, do laundry, tie a tie, or pay taxes. Because teaching my son how to do these things and be a productive member of society both outside the home and inside starts with *me*. Because it's okay to let your child be a child, but still teach them lifelong lessons along the way.

My son will never be too "manly" to cook or do chores. He will be the kind of man who can come inside from changing a tire to check on his pot roast. Who can properly sort his laundry and mow the lawn, too. Remember, parents, a man who believes he shouldn't have to cook or do chores was once a boy who was never taught any better. **—NIKKOLE PAULUN**

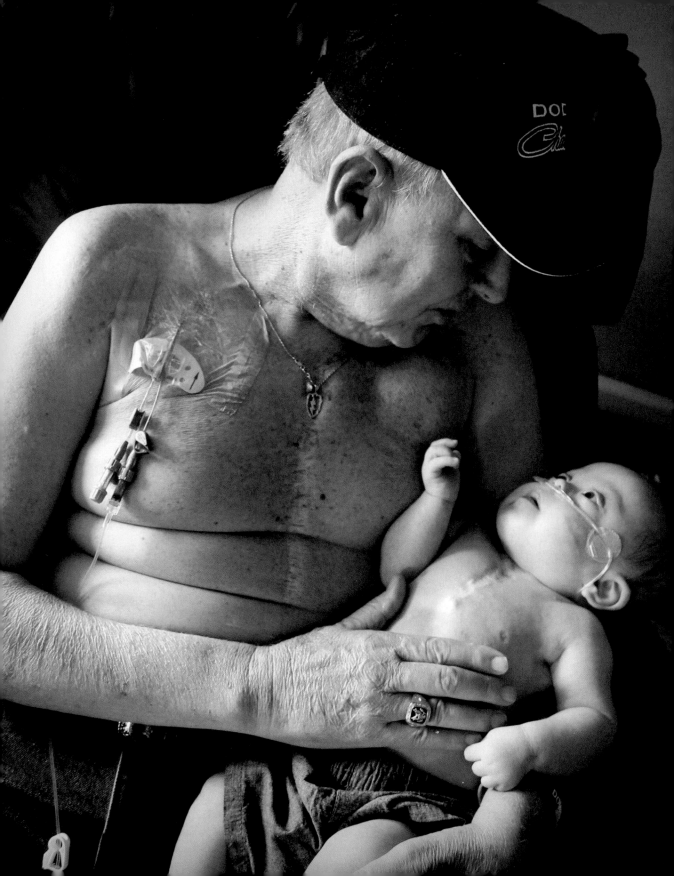

MY DAD

has had two open-heart surgeries, eighteen stents, a pacemaker, artery disease, diabetes, a massive stroke, and too many mini–heart attacks to count, leaving him with 10 percent heart function. He has been battling this for twelve years now. Kolbie had his first open-heart surgery when he was four months old. He was born with a heart defect, pulmonary vein stenosis, pulmonary hypertension, premature lung disease, kidney disease, and Down syndrome. He is ten months old and has spent seven of those months in the hospital.

This past year has been extremely hard for our family because both have been in and out of the hospital with us not knowing if they would make it home. My dad just sits and holds Kolbie for hours, and they chat about their matching "zippers"! You can definitely see in this picture the love and bond these two miracle fighters have!

There is so much hate and violence in the world, yet you have two people fighting to be here each day! I will cherish this amazing picture the rest of my life! **—SUNSHINE MOODY**

WOW,

what a day today has been! In the Walmart parking lot I saw a homeless man sitting on the side of the road with a sign saying "Dog in Pound—Need Help." Of course, what do I do? I've seen every sign in the world except that one. I've seen "I need a beer," "Lost my job," "Need help"— I could go on forever—but never this sign.

I tried to pull to the side, and, of course, everybody's pissed off because I'm blocking them, and I asked him what his deal was. I gave him my card. I asked him how much it was to get his dog out of the pound. He said $120. Well, I had $8 to my name. I told him I'd see what I could do. First I called the pound to verify the man's story; they said, yes, it was $120. I asked why so much. The pound said because $35 was for an impoundment fee; then they gave it rabies shots and a heartworm test (the dog was negative), and put on flea prevention. They said the dog was in good shape.

So now, since I don't have a dime to my name, I call a dear friend and I tell her about this guy. She says, "Well, go back and find out his story," so I did: thirty years old and his name is Patrick. I talked to him for a few minutes, and he told me his circumstances and stuff. I told him, "I'm getting the money to get your dog out, so let's go down to the pound."

Me and Patrick go down to the pound, they give him all his paperwork, and they get a copy of the rabies

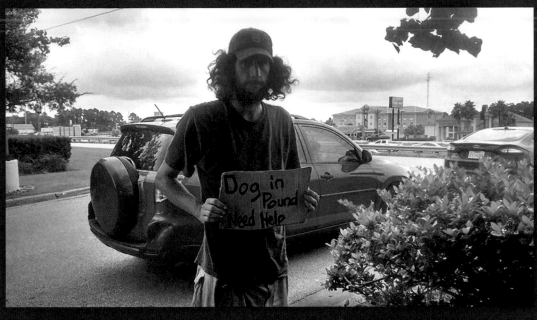

test. Frederick is the dog's name; when he came out of the pound, he was shaking, he was so happy to see his owner.

Sometimes you just have to dig deeper and do what's right in your heart. That man loves that dog. On his backpack were the dog's bowl and toys. He's helping the dog against the world. Patrick was very, very grateful; he had tears in his eyes when the dog came out. We've all been in bad situations in our lives, so remember to always pay it forward. You never know who that person might be that you can help, but I know for a fact that man loves his dog, and he tried to give me the money he had collected. I wouldn't accept it because maybe he can have some dinner tonight. He said his dog eats before he does. Wow, that sounds like me too. I wish I had the money to get the man a room for a week and let him and Frederick regroup, but unfortunately I don't. All I can do is give him his dog and pray that life gives the man a break. I dropped them off back in the Walmart parking lot in Huntsville and cried when they left.

God, please bless Patrick and Frederick tonight.

—WILMA GARRETT

SAME GIRL. Different angles.

If I'm going to show you the posed, put-together, professional sides of me, I'm gonna make damn sure you see the not-so-flattering sides too. Because contrary to what society has taught us to think, our worth isn't measured by how many belly rolls we have, or how many dimples we have on our booty, or how much jiggle hangs out on our arms.

Loving ourselves exactly as we are is hard. Because we've been told for years that we're not good enough until we (insert any of the thousands of ideas of perfection that have been fed to us over the years). But I call BS. I say that the real magic happens when we embrace who we are, at every angle and size.

This doesn't mean I don't also struggle with embracing this body I was given, but it does mean I understand that working on loving me is the most important job I will ever have.

Our bodies aren't broken. What's broken is the message society is trying to tell us by airbrushing everything, erasing dimples and rolls and fluff.

So even though it's really hard, let's remember that we are worthy and beautiful and special and *alive*. Go on and love yourself today, because *that* is what's inspiring. **—ASHLIE MOLSTAD**

my first priority

ONE week after bringing Isaiah home, I missed the hospital. Could I really be that insane to miss a place like that? Could I be even more insane to be feeling so helpless, so terrified, so vulnerable?

What about feeling guilty and not knowing why you are feeling guilty? These feelings and emotions were a constant weight pulling me down.

I felt so guilty that I tried making up reasons to feel guilty, such as telling myself I'm not a good mom and that I can't do this. I would act like I had everything under control, I would put on a continuous smile, while inside I was screaming for help. Asking for help would make me weak.

"You are a mom now; you can't be weak."

"You are a terrible mom."

Anything I thought or did would come down to me telling myself these things. It was a repetitive cycle.

Have you ever felt that dark, sinking feeling? Like weights holding you down beneath water? Like your heart being ripped out of your chest? Like your stomach dropping? I felt all that, and it changed me. It made me fall into depression so easily. Now that I have a tiny human to take care of, he is my first priority. I never really put the time into taking care of myself, especially because I felt so gross about how I felt. I wanted to ignore it for as long as possible.

When you start having some intense thoughts, such as wondering if your son would be better off without you, or having

some real trouble trying to find any self-worth, you realize there is an issue going on deep down. I've dealt with depression and anxiety before, and I always seemed to push past it. But this time around, postpartum was just too much for me. It's not something you can fix overnight. It's not something you can change by thinking differently or going outside for a walk on a nice day. It's not something where you can tell others how they can cope or how they can heal. Sadly, it's not simple.

Postpartum depression and anxiety can be looked down on by many because this is supposed to be the best time of your life. But listen when I say we still love and adore our babies. I'm not sure why some go through this and some don't. Either way, it doesn't make anyone more or less of a mother. It doesn't make anyone more or less of a human.

I have my good days, and I have my bad days. The good days are simply amazing. I have this perfect little human who always smiles and brings me so much joy and warmth. The bad days make me forget I ever had a good day. They come right when I finally have a sense of hope. I feel heavy, and I feel helpless. I feel like crying, and I feel like hiding. It's so complicated to explain to someone—even more so if they gave birth but didn't experience any postpartum depression and anxiety themselves.

But every day is a struggle, and every day I need to push to get better. I was blessed with my son, and my son needs me. Your baby needs you too. **—RACHAEL BUROW**

the look on his face

I HAD AN EXTRA TICKET for the Pittsburgh

Steelers football game on Christmas. I was originally going to sell it—until I listened to "Give Love on Christmas Day" by Johnny Gill. In the song, there's a line about giving love to the "man on the street," which gave me an idea: instead of selling the ticket, I invited a "man on the street" to the game.

This is Ricky, or Stretch, as he's known on the streets of Pittsburgh. He's forty-three years old and has been in the Burgh his entire life but had never been to a game. He and his friends on the street look out for one another; one of his friends was able to take his backpack and other belongings until the game was over. He told me he's lost twelve friends this year to heroin overdoses and a few other tough stories. I offered to buy him anything he wanted during the game, but he never once asked for anything; nor did he accept any offers of food or money after the game. He told me the gift of being invited inside the stadium to watch the game was the best Christmas gift ever for him. The look on his face during the game was something I'll never forget because it reminded me of my own blessings. It also reminded me of what this day is all about, in that the ability to give is a blessing in itself. I saw this as a way to remind us all to give, to give back, and/or to make a difference when and where we can. Merry Christmas!

—ERNEST FREEMAN

THE MAN in this photo is the best stranger I have ever met. Last week I found myself terrified and alone on the side of the road, holding my two-year-old daughter as she worked through a febrile seizure.

Mark helped me to a parking lot, bought me water, sat with me as I composed myself and waited for Quinn to regain consciousness, and then ultimately got us to the hospital.

As it turns out, Quinn is fine (this was her fourth seizure), my husband is never allowed to leave town again, and Mark makes great pizza!

If you are in the Naples, Florida, area, please support this wonderful small-business owner and his wife at Palumbo's Pizzeria. **—ANGI PIETZAK**

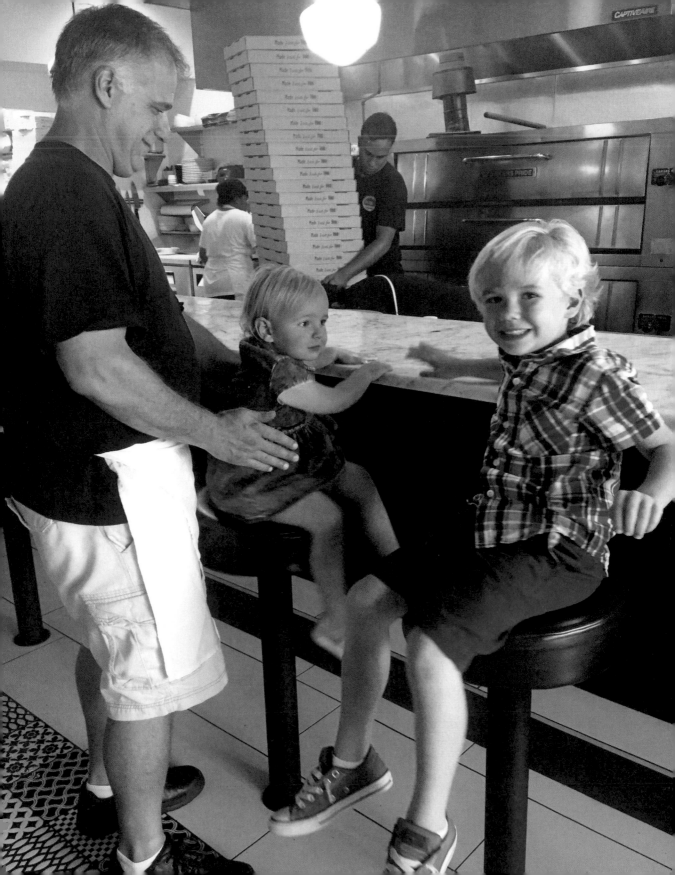

Dear Jorge and Leonor,

I am compelled to write to tell you how beautiful your children are, inside and out! This can only come from the home, your patience and guidance, the examples that you set and teach.

I have a child on my bus named Jackson. Both of your children have shown him much compassion and support. Every day your children ask if they can sit with Jackson.

Some days Jackson is a little sad getting on the bus but as soon as he sees Annaliese and Jorge he smiles. Jackson has difficulties walking and it takes a bit for him to get to his seat.

Today Annaliese looked out from around her seat and said, "come on Jackson, you can do it" and when we arrived at school Jorge took it upon himself to carry out his backpack!

I know you know how wonderful your children are, but I wanted you to know that it shows!

Cindy ♡

Cindy Clausen
Bus # 50

THERE IS HOPE FOR AMERICA.
—CYNTHIA CLAUSEN

♡ **KIRSTEN BUCKLEY CARTWRIGHT:** Parenting goals right here. I don't need my son to be the smartest in his class, but I'd sure love it if he were one of the kindest.

use the good china

SATURDAY we bought a Bundt cake at a bake sale at our local farmers' market. It was on a china plate. I offered to bring the plate back to the organization but was told that the plate came with the cake.

At home, I sliced and froze the cake for individual servings. I washed the plate, and lo and behold: this was my mother's china pattern. Unlike most women, she felt, "Why have nice things if you don't *use* them?" She used her good silver for dinner. She used her good china for dinner. Her china got used so much so that it wasn't salvageable when she passed away.

Now I have a reminder: everyone, use the good china. **—AMY S. POKRAS**

AMY JO PURDY: A reminder to never save the china, the perfume, the shoes, the dress, and so on for a special occasion; every day is a special occasion worth celebrating.

SARAH LOVELACE: I inherited my grandmother's china when she passed away. It's gorgeous. I use it as my everyday dinnerware. I know the pieces are extremely expensive to replace, but I don't care. This china reminds me of my grandma, and I believe beautiful things are meant to be seen and experienced. Not hidden in a cabinet and forgotten about.

WHILE

riding my bike home from work, I spotted a young girl (fourth grade) sitting on the curb in front of her house with a sign that said "Ru's Salon." Every person that walked or rode past, she asked if they wanted their hair or nails done for $1. I watched three people tell her no, and each time, she put her head down in disappointment. As she was getting ready to sit down, I yelled from my bike, "Hey, whatcha up to?" She turned around with a big smile on her face and said, "I have my own salon, and I'm doing nails and hair for a dollar. Do you want to get yours done?"

The young girl, whose name was Rhuin, and I talked for a while about her day, her salon, and her summer. Unfortunately, I had somewhere to go, so I couldn't get my nails done then. I told her good-bye and said I'd stop by tomorrow. A block or two later, something told me, "Forget your plans and turn around." I turned around and stopped at a store to get change and biked back to "Ru's Salon" to find Rhuin packing up to go back inside. I called her name, and her face just lit up with a huge smile. She was so excited that I came back.

During my nail-painting session, she talked about being outside for hours and talking to so many people, but everyone said "No" or "I'll be back tomorrow." I was her first customer of the day. She also said she thought people said they would be back tomorrow only because they didn't trust her nail-painting skills because she was a little girl. Rhuin promised me that she would be extra careful with my nails, so I could tell all my friends about her. She went on and on about her business plan to start off charging $1 and then moving up the prices once she established some customers, LOL. Her exact words: "When my mom takes me to the nail shop, she pays fifteen dollars to get my nails done, and I am charging only one dollar, so I have the better deal."

I don't know about you, but what fourth grader do you know that would rather make money sitting on the corner *not* begging but doing something she loves: hair and nails. I know this was a very long post, but the moral of the story: support our babies and young people. **—DAEJA CARSON**

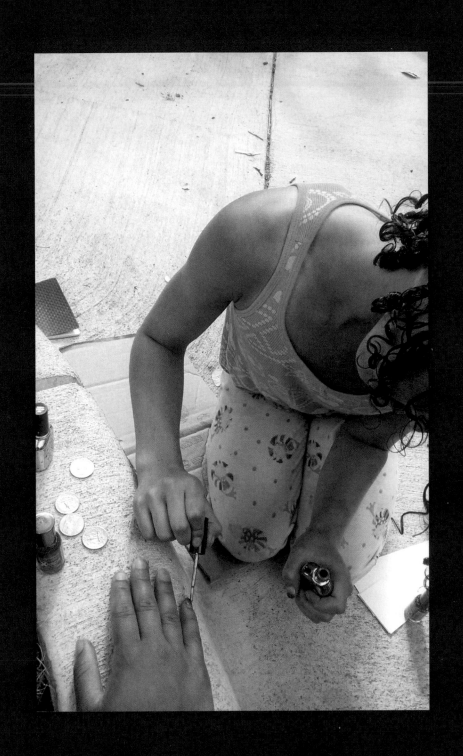

the power of pink

TODAY

I painted a new resident's nails at work, and as we were going over colors, she mentioned she wanted clear. The only thought that came to my mind was "Clear? That's no fun." I asked her why she wanted clear, and she said, "My hands are ugly; I don't want to draw attention to them." I then carefully responded, "Your hands tell the story of your life. They tell the story of love—of care and adventure. These hands have touched and held things that most people can only wish to one day." And with that, she went with the color pink for her nails.

Sometimes what we are so insecure with, others find beauty in. **—BRANDALYN PORTER**

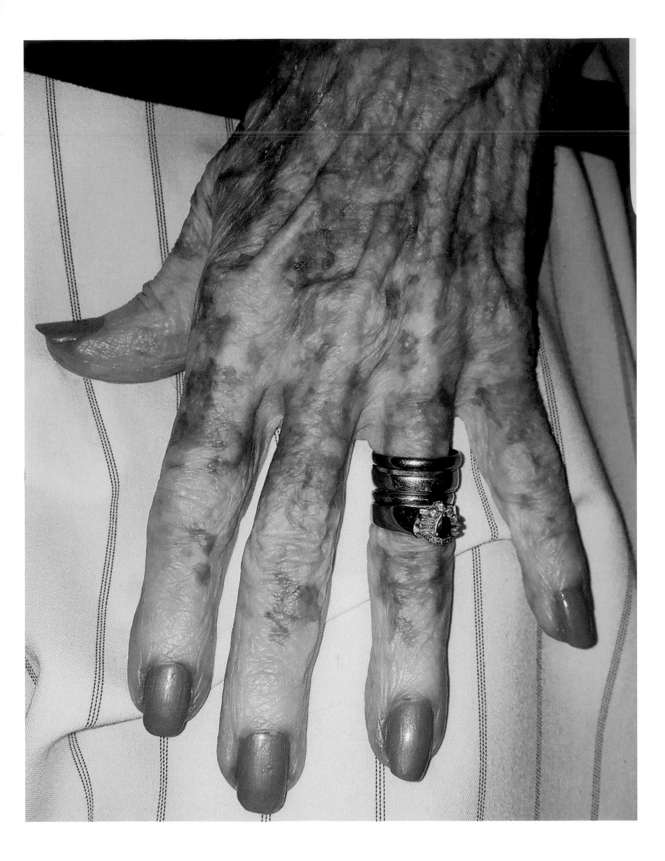

couldn't miss dinner

LOVE

MY AUNT gave me this picture of my grandparents last night. They met on a blind date. He proposed three weeks later but wouldn't marry her until he got out of the army. She waited four years for him. Four years later, they were married, and had seven kids! When he retired, he would set the breakfast table every morning and wait to eat until she woke up. When he got sick with Alzheimer's, and we would watch him, I remember him asking us to write down his address. My mom wrote it down on a napkin. He folded it and stuck it in his back pocket. He would then periodically pull it out and check because he "couldn't miss dinner." Love is beautiful. **—KIRSTEN NOWAK & ALLY FERREIRA**

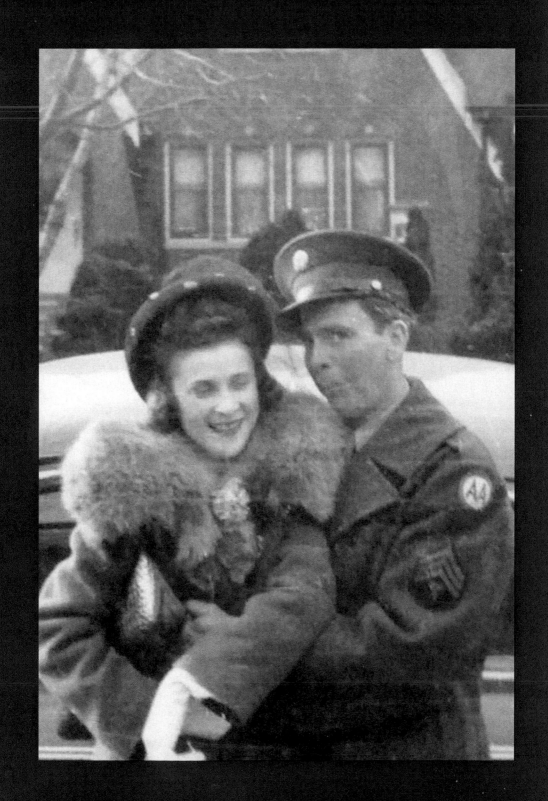

hats off to you

WHEN

my baby, Gracelyn, was born, the hospital gave me two knitted hats, but one has always been special to me; the colors are beautiful and so flattering on her, and she wore it home from the hospital. She just happened to be wearing it today as I took my girls for a walk around the track in their double stroller. Everyone has always stopped to ask about the hat; it's just that pretty that it stops people in their tracks.

Well, as we are going round and round, this sweet older lady smiles each time she passes. Then she stops me and says, "Two girls, huh? They are beautif—

"Oh, my goodness! Did you get that hat from the hospital? I'm pretty sure I made it!"

Sure enough, this sweet lady walking her dog around the track is the very same person who knitted my favorite hat! She tells me about how she had a stroke and was paralyzed on one side, and she had trouble focusing, so to help with that, the senior center (which is where the track that we were waking on is) taught her how to knit. The teacher even said to her, "That yarn is a little thick for a newborn hat," but she carried on because she wanted to finish up some yarn she had left over, and it was winter, after all. Little did she know just how much the person who received it would love it!

So today I met Ann, the opera singer who now knits hats for newborns. These pictures show just how big Gracelyn has gotten. Soon she will no longer fit in this wonderful hat! **—CASEY SCARFF**

TODAY

I went into a tattoo parlor for the tattoo I've been wanting forever to cover up scars from hurting myself as a teenager: it's a compass, but instead of north and south, I have my kids' initials.

The tattoo artist opened her shop early just for me. We chatted as she drew out the design. After a moment, she grew silent before blurting out, "You know, you remind me of someone I used to know."

I looked at her carefully. Two of us from such different worlds. "Where did you know her from?" I asked.

She took in a deep breath. "From a hospital."

I felt a tingle down my spine—the one that tells you something big is about to happen.

"What hospital?" I asked.

She named the one that takes suicidal teens. My mouth dropped open. "I was there too."

She screamed, "I knew it!" And grabbed me in the biggest bear hug ever.

Yes. She was there. When I was a teen. When the scars on my arm were fresh and covered in gauze. And now she was the one to put the tattoo over them that says *"Sozo"*: healed, whole.

I look at it now: my arm, a place that once represented hopelessness, now represents love—more beauty from ashes than I ever could have dreamed. **—CeeCee JAMES**

KATIE BERTRAM: I too have a scar cover-up. So freeing and self-liberating. Even though the pain is gone, the scar is always there as a reminder. No more hiding it; just pure beauty to look at. Love to all!

REBECCA WOLF: We always assume everyone else has it all together, and we are the only ones drowning. But really, we're all drowning separately, feeling alone and isolated. What if we made an effort to support one another?

HAYDEN: "I wanna go get water!"
(Points to water fountain.)

BRADY: "Well, Hayden, you know it's your birthday. You can get whatever you want!"
(Bends over and tells Hayden to get on his back.)

—TONYA WHITE

chivalry is far from dead

LOVE

BRAXTYN'S next-door neighbor and best friend came over and invited her to play. I gave them an umbrella, and he escorted her to his house with his arm around her! Chivalry is far from dead. **—LISA ROOMS**

ON JULY 7, 2016, at 12:13 a.m., my wife

was dying. She'd just had an emergency C-section and went
into shock. I stood by her head while she was bleeding out and
remembered every fight we'd ever had and the things I never
did for her. I couldn't let her know how scared I was. I stood
in front of my wife, saying my final good-bye! What do you
say to someone knowing it's going to be the last time you talk
to them? I tried so hard to comfort her and tell her everything
was okay. I tried to smile and pretend that it was all part of the
operation. They called a code blue, and people started rushing
into the room. She was shaking so much! I kissed her and asked
God, "Please don't take her home." I thought about all the times
I missed church. I thought about how to tell my family the bad
news. So much was going through my mind that I had no time
to enjoy my son. I had to be strong for my family. I had to put
the weight upon my shoulders and walk with this load of having
my wife pass in the operating room. I didn't know what to say.

I didn't want to pray because I thought God would shun me
for not being a good Christian. I was so sorry and asked God if
somehow He could just hear this last request. I was rushed to a
different room and waited for about ten minutes. Jackie finally
showed up, and my heart was so so so heavy with grief. I wanted
to pick her up and carry her out of the hospital as if everything
would be fine. I wanted to leave and have this nightmare be
over! I stood with Jackie for about three minutes, and the worst
happened. She lost about one liter of blood in a couple seconds. I
didn't say anything, I was so scared. I just looked at my wife and

couldn't utter a word. I wanted to say "I love you" and tell her it's okay. I wanted to help her as much as I could. I wanted to stop everything and start all over again. I knew she was dying in front of me.

They called another code blue! This time my heart stopped. I thought, "Why didn't I pray every night? Why didn't I love her like God has loved me!" I died in that room! I truly died! I didn't know what to do again. I watched helplessly as they tried to save my wife. People were running and pushing me farther away from her. She finally uttered a word, and it was like the room went silent. She asked for some water, and I knew she was leaving this earth. They took me and my newborn son to another room.

As we were walking, I saw my mom and family. I wanted so hard for someone to hold me. I wanted someone to carry me like

a kid and tell me it's gonna be okay. I didn't want to be a man anymore. I wanted to cry! I wanted to cry out to God and ask Him why! I stood by my family for about two minutes, looking at everyone and holding back all of my emotions. My mother asked me, "How is Jackie?" I almost lost it and cried like a baby. But I just shrugged my shoulders and said I didn't know yet. I was lying; I knew she was in really bad shape. I wanted to run back in the room and hold her, but I had to take care of my son now. He had to be given antibiotics to prevent an infection from starting.

After about five minutes, I asked the nurses if I could go see my wife, and they reluctantly said yes. The hallway to where my wife was is about forty yards. I walked about five yards and started crying alone. I couldn't keep up this persona for much longer. I was scared to walk back and hear the news. I wanted my dad to comfort me! I'm still his little boy!

I had around thirty-something yards to walk, and Jesus spoke to me: "Gabriel, my son, I love you more than you can imagine. I heard you, and I was there! I saw the C-section. I helped the doctors find the problem. I saw when she hemorrhaged and made sure they caught it really quick. I was waiting for you in this hallway when you wanted your father. It's okay to call on me. I will always love you. Just as you asked me to save your wife, I've been asking my father to save yours." I walked with more love in my heart for everything in that moment. My wife and son are doing great and will be discharged Sunday. If you see me at church, don't ask me where I have been. Just say, "I'm glad to see you're home!" **—GABRIEL WILLFORD**

PUFFY FACE, droopy milk-filled boobs, wider hips,
and belly full of stretch marks! That's my postbaby reality—no "bouncing back" here!

And you know what? I couldn't give a sh*t! Because I'm not the same person I was before I had babies, so why would I want my body to reflect something or someone I no longer am?

Those droopy boobs fed my babies and grew them up big and strong. Those hips and that rippled belly were home to my little babes for nine months.

It might not be the "transformation" body so many ogle or aspire to! And, sure, some days I wish it didn't jiggle so much and was a bit "firmer," but then I just remember the awesome stuff it's done and cut myself some slack and go eat a cheeseburger, because we earned it. **—OLIVIA WHITE**

JAZMIN ESTREYA PARROTT: My four-year-old son was in the changing room with me the other day. I had picked out a dress. (It was actually the first one I saw; usually I spend hours in the store and walk out empty-handed.) Anyway, before I had a chance to pull it down, I thought, "Wow, this can work!"

My son then said, "You look pretty, Mommy." Obviously, my heart melted! I was now inspecting every inch of my body in the rather large mirror, when all the horrible, negative thoughts just started flooding my mind! Disgust, anger, sadness, rejection of myself—I ended up putting the dress back. I was even more angry that I didn't believe my own son! I am working on accepting my "new" body. Of course, I'm also working on being healthier, but nothing will work unless I accept myself first. I know that. I love my children so much, I wouldn't change anything, and I love the fact that my son sees me for who I really am: his pretty mommy.

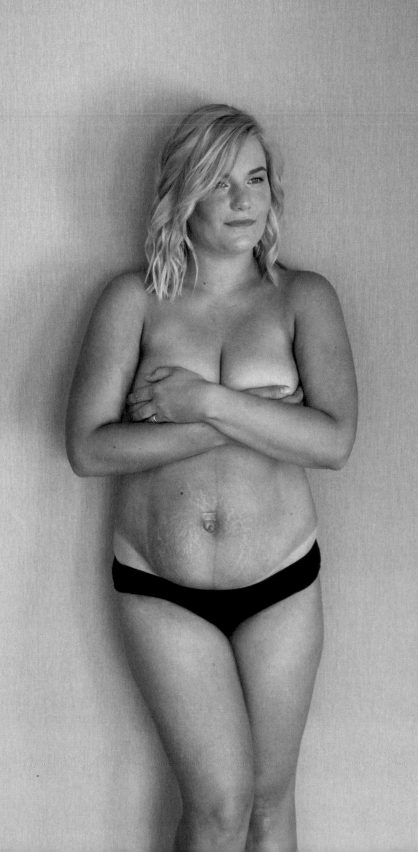

DEAR KARTER,

For all those nights you had to fall asleep in the library, for all those times you had to watch cartoons alone because I needed to do homework, for the early mornings in day care because I needed to be in class, for being the last one there because I had to work, and, most importantly, for the moments of separation because I needed to get this done, thank you. You are the motivation for my heart to keep beating. I love you more than words can say. I finished because you needed to see me do it. I'm not strong because I want to be, I'm strong because I'm your first example. We've seen a lot and overcome a lot more.

To infinity and beyond, a mother's greatest love.

—JELINA SHEPPARD

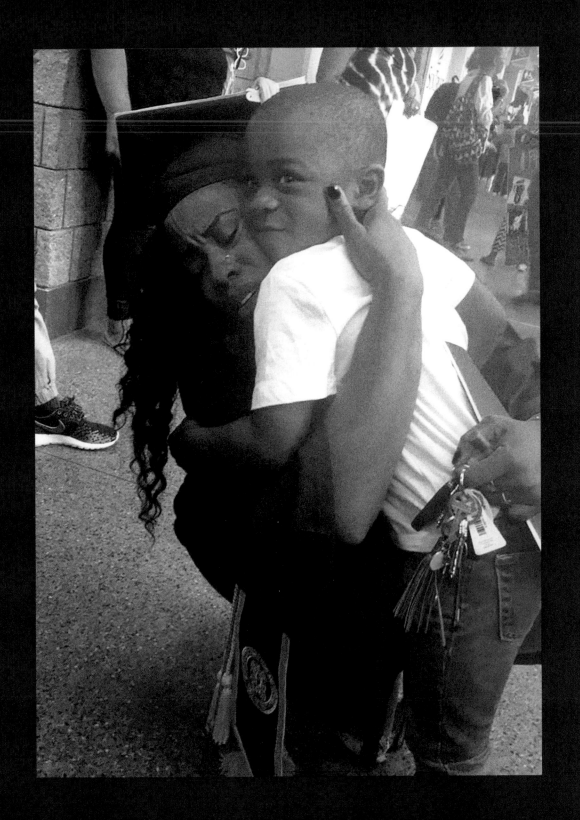

be a servant

LOVE

THE FIRST

photo was taken right after I proposed on the coast of Barbados in June of 2016. The second photo was taken the following day. After the proposal, we went to a fancy dinner at an upscale restaurant and ran the bill up to $72. On the way back to the hotel, we began to laugh and ask each other, "What were we thinking?" We had never spent that much on a single meal (or even two combined). We typically eat in and then have leftovers. We don't make a ton of money, and that's okay. I'm an athletic trainer. Athletic trainers don't make a lot of money. Thankfully, I didn't get into the profession for money, I got into it to serve others and provide the best health care I could. We rent a house, have a car payment, student loans, and three dogs who eat better food than we do. We save what we can so that we are able to take trips like these.

Recently, we had been fighting and arguing more. I get down in the dumps after we fight. Or mad. Or some combination of the two. And then I look at these photos. I remind myself why I work and try to pick up any

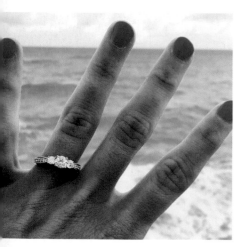

extra shifts for a future plane ticket. Look at her smile and her eyes. And the cutest nose on earth. I remind myself how I am a servant. In my profession and my relationship. It's easy to get mad and tell myself I'm right and she's wrong. It's a little tougher to bite my tongue, swallow my pride, and realize that one fight isn't worth being "right." I know I make her mad sometimes. I don't clean my car or the house enough. I forget drinks on the nightstand. I snore and wake her up. I steal covers in the middle of the night. I dry her fancy clothes and unknowingly shrink them. But I wouldn't trade it for anything. I'd much rather be at home watching a movie with her with $27 in my bank account than have millions and be home alone. Be a servant. —ALEX GUIN

I LOVE Abilene Lowe's—way to go! This is a retired vet who struggled to get a job because he needs his service dog! Lowe's hired them *both*! —JUDY DECHERT ROSE

♥ **SHAWN WHITE:** If anyone has ever been stationed in Abilene, Texas, you would know that this town is famous for the way they treat their military members and veterans. I've had my meal paid for by strangers a bunch of times!

MY SON has autism, and haircuts have been somewhat challenging for him. We spent four years bouncing from salon to salon—a new one almost every haircut—and we were even asked to leave one barbershop in the middle of a haircut. We've been going to Supercuts in Media, Pennsylvania, for almost a year now, and I want them to know how truly grateful I am for their patience, understanding, and, more than anything, acceptance. Christine has become our regular hairdresser, and today she gave Perry a haircut too—and that means the world to Braeden.

—KATHLEEN TARZWELL

MY TWELVE-YEAR-OLD son and I were
pumping gas when he noticed an elderly gentleman having
difficulty pumping his gas. He looked at me and, without
saying a word, jumped out and walked over to him. He started a
conversation, and I watched as the man handed the pump to my
son without hesitation. My son even went into the gas station to
retrieve the man's change that he had left over. The man started
to hand my son money as a reward, and he refused it and just
gave the man a hug. My son did all this on his own without any
prodding from me. I drove away in tears and so proud of my son
that day. —A. JACOBS

no baggage here

IF YOU walk into our classroom now, you'll see a bag hanging by our door. This bag contains everything our class carries to school that we consider problems or bad things in our lives. The things that distract us, sadden us, or make us angry.

Something I have found in common with every student conversation about something upsetting them is that the student believes he or she is the only one who has a problem, hard life, family problem—whatever it may be.

So today we all anonymously wrote down on paper what was heavy on our hearts, crumpled them up, and threw them in the bag. I mixed them all up, and students had to pick one and read it out loud. I could not believe some of the things they have to deal with at home, and neither could their peers. It resulted in a lot of tears, a lot of hugs, a lot of "I had no idea so many people had hard things to deal with too."

The message of the project, as I discussed with them, is that you never know the weight people are carrying. It is so important to remember that when we interact with others. I wanted them to see that they were not alone and that they had a whole class of people who could relate to them and support them.

Our stories now hang by our door as a reminder of the "bags" others may carry with them. **—KRISTEN McCULLOCH**

ON MARCH 27, 2009, I gave

birth to a beautiful baby girl, Bailey Elizabeth. I was
just nineteen years old. For three years, it was just the
two of us.

When I was twenty-three, my now husband,
Jason, and I went on our first date. From that day,
I knew I was going to marry that man. I eventually
introduced him to Bailey. Watching him with her, the
way he loved her as his own, made me fall in love with
him even more.

We had been dating for about two months when
I really saw the impact Jason was having on Bailey. He
was holding her, and she looked at me and said, "You're
my mommy." Then she wrapped her little arms around
Jason and said, "And you're my daddy."

The happiness in her voice and the smile on
Jason's face I will always remember. Bailey finally
knew what it was like to have a father in her life. To
have a man love her and be there for her. To see him
love her mom the way every woman deserves to be
loved. We were a family.

Fast-forward to now, married with two more
children. Bailey started asking if she could have her

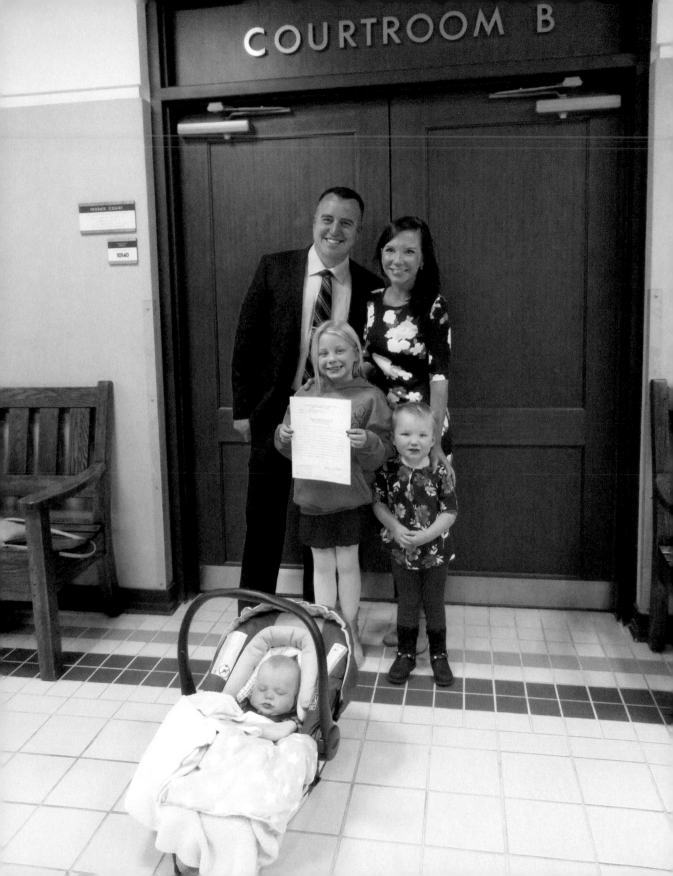

last name changed to Jason's. It was something Jason and I had talked about. Once she came to us, we knew it was time. So here we are today. What a road it has been.

"I didn't give you the gift of life. Life gave me the gift of you."

Adoption is truly a beautiful thing. Watching the love that Jason and Bailey share is truly amazing. He was a father to her from the moment she came into his life. And as of today, November 29, 2016, Bailey Elizabeth Smith, we can finally say it's official.

Smith, party of five! **—EMILY SMITH**

TRENT McCAIN: I love this story, as it's the same with my daughter. I was a bachelor until thirty-five, never married and no kids. My wife and I started dating when her daughter was four. She had never known her biological father, and he has since passed on. Dating was going well, and one day her daughter asked if I would accompany her to Doughnuts with Dad at her preschool. I accepted, and she introduced me to all her friends as "my Daddy." Let me tell you, friends, I was in tears. Eventually she and I decided that I should ask her mom to marry me. During the wedding, our minister performed an adoption ceremony, and we had paperwork finalized with the judge the following week. So I celebrate two anniversaries every year. Our daughter is now ten, and I wouldn't trade her for anything.

OUR home-care company held a photo shoot today of some of our amazing clients who are living life to its fullest, all thanks to the caregivers who help them with companionship, everyday activities, and even personal care! I couldn't resist capturing these two with my phone.

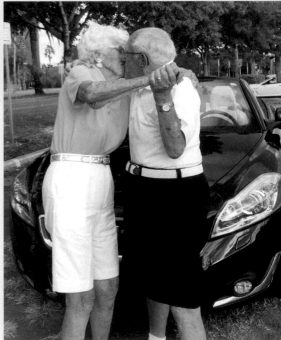

Married for just eighteen short years, he is ninety-five and she turned one hundred years young last spring! They pulled up in their convertible with their caregiver in the backseat. The happy couple had huge smiles and are still madly in love!

Thank you to spouses, grown children, neighbors, friends, and professional caregivers who grant independence and happiness to those who might not otherwise have it! I know it's a hard job, but you truly make a difference! **—CARRIE CASH**

without hesitation

LAST WEEK we brought our six-year-old son, River,

to the Clarks Village outlet store in Street, England, to be
measured for school shoes. Being autistic, he really struggles
with crowds, long queues, and noisy places. The store was
heaving!

I knew there was no way he would cope with that
environment, so I explained the situation to a staff member.
Without hesitation, Aaran led us away from the noise and
crowds to a staff room and placed a Do Not Disturb sign on
the door. He was very patient with River, who was anxious,
and went and got lots of different shoes for him to try on.

We left with a great pair of shoes and a very happy boy.
Aaran also gave us the store number and said they'd happily
book us an appointment before the store opens so that it's
quiet. Autism acceptance at its best!

Thank you, Clarks in Street, and a massive thanks to the
shop assistant, Aaran Daniells. —GEM SALTER

A LOT OF PEOPLE ask why I have three wedding
rings and one that's broken. The broken one is not really broken:
it had to be cut off when I had preeclampsia with my first child. I
got a new set, but I couldn't let go of the cut one. To me it's more
than a broken or cut ring. My husband and I got married when I
was nineteen and he was twenty-one. We were young and in love
and pretty much broke. Our first set of rings maybe cost $300
total for mine plus his. To me this broken ring is a symbol of love
and never-ending faith. We have been through so much in the
past almost ten years, but I wouldn't trade him or my broken ring
for anything. I will always wear my broken ring. It's my proof
that even though something may be broken or not up to society's
standards, it doesn't matter. What matters is the pure love and
strength we both have for each other! **—LAURA FLOYD**

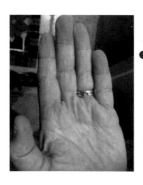

JON DANIELLS: This is amazing. My
wife had to have her original wedding
ring, which cost about $50, cut off
during her pregnancy with our second
child (who is now thirty-one years old).
Long ago, I bought her a new ring, but
she still wears both!

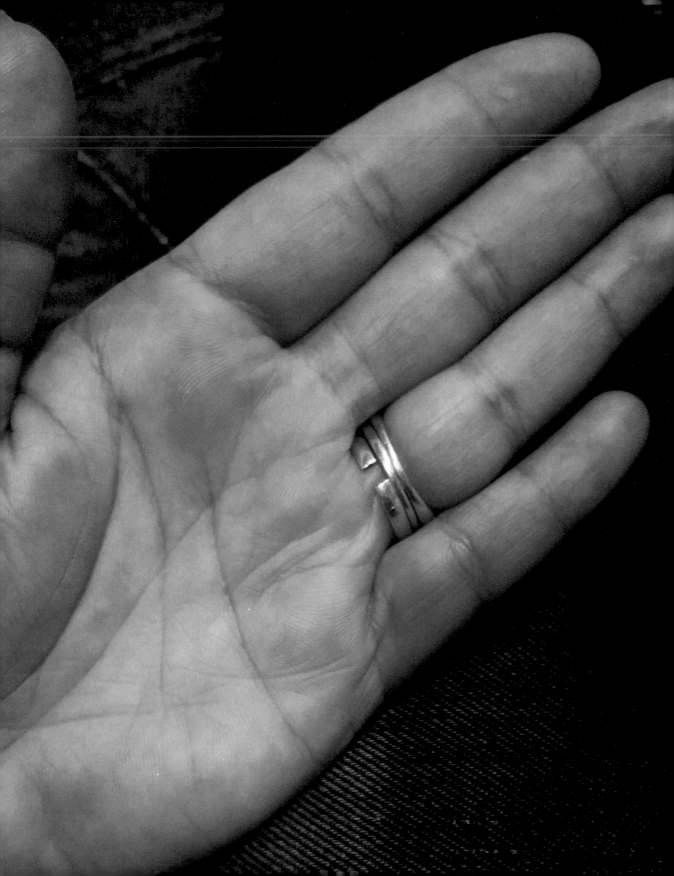

THIS MORNING at preschool drop-off, I could tell that

my daughter had noticed some of her new classmates staring and whispering when they saw the fresh bruising on her face from her latest treatment to keep her port-wine stain birthmark healthy. Instead of getting upset or self-conscious, Lydia simply walked over to her cubby, pulled out her copy of a book called *Sam's Birthmark*, and handed it to her teacher to read to the class. She isn't even three yet, but her resilience and ability to care for herself blows me away. I cried nearly the entire way to work—not because I worry how her peers will treat her in the years to come but because I know this girl is gonna do big things! **—KELLY WILSON BOSSLEY**

♥ **MARTHA WARDLAW GRIFFIN:** I am the coauthor of *Sam's Birthmark*. When I see posts like this one about Lydia, I tear up! Our son was born with a port-wine stain covering half his face. My husband, Grant, and I soon realized there was not a positive-message children's book in which the child character had a birthmark, so we wrote one. Connecting with birthmark parents from around the world has been truly amazing! Our goal is to spread vascular-birthmark awareness and acceptance. When you buy a book, you get a complimentary second copy to give to your school, doctor's office, church, and so on.

THIS IS MY DAUGHTER Autumn.

She was born with a hemangioma [a red-and-purple nonmalignant tumor made up of blood vessels] that covers most of her upper torso! When anyone asks about her skin, I tell them that Jesus just kissed on her a little more before He gave her to me. —BRITTNEY JEAN

TODAY
I received my wedding gown back. I sent it off earlier this year to be made into angel gowns for babies who don't make it home from the hospital, and I'll be donating them to the neonatal intensive care unit at Vanderbilt University Children's Hospital.

Seventeen little gowns were made from my dress, and, as beautiful as they are, I pray they are never needed. **—JUSTI BATES**

145

I DECIDED to take my kids out to eat at Red Robin

before going to our school skate night at the ice arena. I specifically asked for a server I used to work with, and the greeter sat us at a table that was very close to another. The woman at the table immediately looked uncomfortable and held her hand over half her face as if she didn't want to look at us. Her husband got up from the table and whispered something in our server's ear. He then immediately moved them to another table away from us.

Now, this wouldn't be the first time someone moved when they saw three kids sit down by them, but I couldn't help but be angry. Like, what do you think my kids are going to do, throw food? Stab you with a fork? Anyway, I asked my server if they moved because of us and couldn't help but be annoyed by the whole thing. He bent down to the table and said, "They recently lost a child." In that moment, I felt so ashamed. My heart literally skipped a beat. I felt horrible for her, I felt horrible for judging her. So I did the only thing I could think of: I paid their bill and asked the server not to tell them who it was.

Well, they must have figured it out, because as we were leaving, she stopped me. Trying so hard to hold back tears, she said, "Ma'am, I didn't want you to think because—"

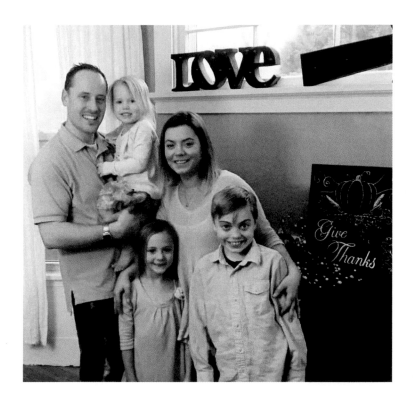

I interrupted, and since I was about to cry myself, I just gave her a hug, and she whispered, "Thank you." I told them, "Have a good night." I feel awful for their loss, but I'm grateful this encounter happened. It reminded me to never snap-judge someone; you never know what others are going through. It also reminded me to live every moment with my children, to savor the good and the bad, because they are here, and they are mine. And also, of course, to always be kind.

—ASHLEY WADLEIGH

I FORGOT

to post this Thursday. After all that had happened that day (and probably due to the lack of sleep this past month), I was really out of it, but we went to Olive Garden in Little Rock after Ellee's tests at Arkansas Children's Hospital. She was starving. I was trying to make a bottle, and I spilled it all over me and the floor and had to make another one. Our waiter had watched all that had happened. He brought our salad and breadsticks and said, "Here, let me feed her, and you eat." This melted all of us, and this is what we need more of! He fed her, I ate my salad and bread-

sticks, and that milk on the floor got cleaned up after we left because he just understood! He didn't even know what we had gone through that day and showed us love and understanding—not gotten irritated that I had made a mess and my baby was screaming. Gosh, I wish I would have gotten his name, because he deserves the recognition! It's the Olive Garden on Rodney Parham Road in Little Rock, Arkansas! **—DALLAS FRENCH**

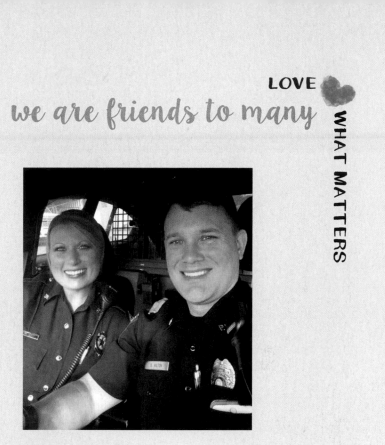
ALL YOU MAY SEE in this photo is two
smiling police officers. But there is more. We are husband
and wife, parents to four beautiful girls, we are a son
and a daughter, a brother and a sister, a grandson and a
granddaughter, a niece and a nephew. (Steven is also an
army veteran.) We are friends to many. Before you say
hateful things and put all officers in a category, remember
that we are all individuals attached to a delicate, thin blue
line. We are attacked daily and get killed just for putting on
a badge.

This photograph was taken on Thanksgiving Day. My
husband and I both decided to work, giving up time with
our family so the community would be safe.

We bleed blue! All lives matter. **—BRITTANY HILTON**

THE BOY WHO LIVED.

My last pregnancy, with my son Brayden, took a horrible turn when I hit seventeen weeks. We went in for a gender ultrasound, only to find out there was little to no amniotic fluid surrounding him. There was nothing doctors could do for us then, because Brayden had not reached a viable age. I was told to try to stay pregnant until I was twenty-three weeks, because that was the only thing to do. At twenty-two weeks and six days, tests confirmed that my water had truly broken, and I was admitted to the hospital on bedrest. Brayden would later be born at twenty-seven weeks and six days, and stay in the hospital for seventy-six days.

The choice to be admitted was obvious to me, but it was not easy. Brayden was given less than a 15 percent chance to live, and we had a doctor tell us to abort the pregnancy. I personally did not feel like it was my decision to decide whether or not Brayden had the strength or capability to live. Brayden would decide that. All I could do was give him the best chance to live, and that was to keep him inside me for as long as possible. Everything we chose was to give him that chance.

People who know me best know that I am a big Harry Potter fan. I grew up inspired that it was Lily Potter's love that saved the life of her son. It was my belief in the power of love that got me through 111 days in the hospital trying to bring Brayden home.

Your mother died to save you. If there is one thing Voldemort cannot understand, it is love. Love as powerful as your mother's for you leaves its own mark. To have been loved so deeply, even though the person who loved us is gone, will give us some protection forever. —Albus Dumbledore

Now, I did not die for my son. As complicated as my pregnancy was, I never came close—even though, as my specialist put it, I lost "*a lot* of

CHAPTER ONE

THE BOY WHO LIVED

blood." My life was never at great risk. I was as at risk as any average person on an average day. We all get into our cars and never think that it is one of the greatest risks we take on a daily basis. We eat and risk accidentally putting food down our airway and never blink an eye at what a risk that is. My point is, I was safe. I was in a terrible situation, but I was safe.

People can argue that I put my own health at risk in fighting for Brayden, and that's true. I bled almost every day from the start of my second trimester until I delivered, sometimes in very scary amounts. But my health was always given priority. I had specialists see me several times every day and an amazing nursing staff who were there for me twenty-four hours a day. The second that my health or Brayden's health showed risks, we were surrounded by a team of specialists in seconds and in an operating room in minutes.

Although I did not die for my son as Lily Potter did, I gave my life for him. I gave up my everyday life—including raising our two-year-old daughter—and laid in a hospital bed for five weeks to give Brayden the opportunity to live. And that gave him protection. The best possible protection: inside me and receiving a mother's love.

That love also carried over into his seventy-six-day stay in the neonatal intensive care unit.

I had to wait almost two weeks to hold my baby; my head rested on the outside of his incubator for hours upon hours. Days upon days. Many moms know how it feels to be discharged from the hospital without their baby, and it's absolutely devastating. My car rides home from the hospital during Brayden's three-month NICU stay were some of the most dark and painful moments of my life.

Choosing to fight isn't easy. It was one of the hardest things I have ever done. We almost lost Brayden the day he was born, a moment that I suffered post-traumatic stress disorder from for a long time. It was a day and moment I will carry with me for my whole life.

But my courage and determination in those moments are what gave Brayden life. He has hopes and dreams and a whole life ahead of him. This little boy who has insanely cute hair cowlicks, dark-green eyes, and one of the biggest toothless grins I have ever seen! You look into his eyes, and he looks back—there is a deep connection there. His unconditional love and forgiving spirit speak to me through his eyes every day. It is the most rewarding feeling I have ever felt.

He is my boy who lives.

He won't go on to live a life defeating dark wizards, playing Quidditch, attending Yule Balls, and going to Hogsmeade like I would have hoped. But he will have a life full of trials and growth. Brayden will have a good quality of life. It's true that he is six months old and weighs only about thirteen pounds, still requires oxygen, and will probably need physical therapy for a couple of years. He is our fighter and will go on to do amazing things.

Life is hard, and there are lots of pregnancy stories that don't have happy endings. But I have talked with several moms who have lost their babies, and they all find comfort in knowing they did everything they could. That is what helped me get through my five-week hospital stay away from my family. I would tell myself, "I am doing absolutely everything I know how to do for this baby. And if that is not enough, then I can find comfort in knowing I did my best, and I can't have any extra guilt because of it."

Please share Brayden's story. I want to spread the hope to all mothers going through difficult times with their children. Whether it be a high-risk pregnancy, a child fighting in the hospital, cancer, a genetic disorder, depression, or anxiety, there is *hope*. Despite all odds, you can fight your hardest.

We chose to fight against all odds to give our son a life. I would go through all that pain again to bring another life into this world.

It is hard. But we are strong. And it is a fight worth fighting.

—**NADINE SHELLEY**

TODAY

I was at Walmart doing my weekly Friday shopping, when the cashier said to me, "I see you in here all the time, your kids are always dressed cute, behaving, and you just seem to have it all together." At the time, I just thanked her and giggled because that's far from the truth, but as I drove home, there was more I wanted her to know about me.

I want her to know I battle a personality disorder every day with anxiety and depression mixed, and I'm a two-time suicide attempt survivor.

I want her to know that I can't always get myself up off the couch to feed them anything more than frozen pizza and cereal.

I want her to know that my son is late for school three out of four days because I regularly forget what day and time it is, despite the toddler-size calendar in my kitchen.

I want her to know I have those "I'm losing my sh*t" moments when I have to lock myself in the bathroom and cry.

I want her to know I wasn't always the most active mom because I used to work eighty hours a week and go to school full-time, and Jayce spent many days and nights with his grandparents.

I want her to know that I hadn't washed my hair in three days, and my kids hadn't had a bath in two.

I want her to know that I was trying to hurry out of there because I had forgotten the diaper bag at home and Brenton was hungry.

I want her to know that once we got to the parking lot, the "well-behaved" child decided to stand up in the cart, and I wasn't

paying attention and barely caught him as he almost hit the concrete.

But most importantly, I want her to know I don't have it together and may never have it all together. I don't know a mother out there who has it all together, but everything we do is done with love for our children, and that right there makes you the perfect mom, and, in our children's eyes, we most definitely have it all together.

From one exhausted mom to another, you're doing great, have that meltdown, let your kids eat the crap out of that cereal, and take care of yourself always. **—CIERRA FORTNER**

love more, hate less

THIS IS

my daughter's father's girlfriend. The sweetest thing ever! I'm super thankful for her because when my daughter visits her dad, his girlfriend feeds her, takes care of her, buys her gifts, and basically treats her like her own. Why do all these moms act so spiteful and jealous toward the other women? *No one* said it was easy trying to be a mother to a kid you didn't have. So when there is someone trying, don't push them away! Because they *don't* need the drama, they *will* leave, and then you're stuck with someone who is the evil stepmom. Yes, they exist! I see them everywhere! A kid can have two moms because, in my eyes, the more people who love her, I'm happy! I would never make the woman feel like an outsider; I'm extremely thankful for her. Ladies, grow up and focus on being a good mom. Love more, hate less! —**AUDREY LOVING**

I BOUGHT
my son Adam a brand-new coat yesterday. I knew we had a chance for snow, and his coat from last year was showing more than his wrists—holy growth spurt! Today he wore it to school for the first time. When I picked him up after school, his sister, Jozlynn, said, "That kid is wearing Adam's coat!" I said, "Oh, they have the same one?" I missed the child she was talking about, and no more was said.

Later I was giving my youngest son a bath, and Jozlynn told me again that a boy has Adam's coat. She continued to say that Adam had given it to him. So I asked Adam which coat had he given away and why. He said, "My friend didn't have a warm-enough coat to go outside today. I had my old coat in my locker that was too small, but it fit him, so I gave it to him so he could play. Then I told him to keep it 'cos he had to go outside and ride the bus home, and he would have been cold."

For all the moments and times I question how we are doing raising our kids, I will have to look back to this. I am amazed and so proud of this little man, who was worried for his friend and wanted to make sure he would be warm. Thinking about it tonight has brought me to tears.

Adam had gotten his new coat only the night before, and there has been such nice weather, it's hard to know what the kids will need outside. There is no shaming here; I'm just so happy our little ones are caring for one another!

—AMANDA BOYER

MY HUSBAND

doesn't have a lot; neither of us does. We scrape and scrape to pay bills and put food in our bellies, but after almost two years of dating, we decided that we couldn't wait anymore, so we didn't.

I wasn't even thinking about rings—I just wanted to marry my best friend—but he wouldn't have it. He scraped up just enough money to buy me two matching rings from Pandora: sterling silver and cubic zirconia, to be exact. That's what sits on my ring finger, and I am so in love with them.

While we were purchasing my rings, however, another lady who was working there came over to help the lady selling them to us. She said, "Can y'all believe that some men get these as engagement rings? How pathetic."

When she said that, I watched my now husband's face fall. He already felt bad because he couldn't afford the pear-shaped set that so obviously had my heart and covered my Pinterest page. He already felt like a failure, asking me again and again, "Are you sure you'll be happy with these? Are you sure this is okay?" He was so upset at the idea of not making me happy enough and of me not wanting to marry him because my rings didn't cost enough money or weren't flashy enough.

Old Ariel would have ripped that woman a new one. Mature Ariel said, "It isn't the ring that matters, it's the love that goes into buying one that does." We bought the rings and left.

Y'all, I would have gotten married to this man if it had been a 25-cent gumball-machine ring. When did our nation fall so far to think the only way a man can truly love a woman is if he buys her $3,000-plus jewelry and makes a public decree of his affection with said flashy ring? Sure, they are nice; sure, the

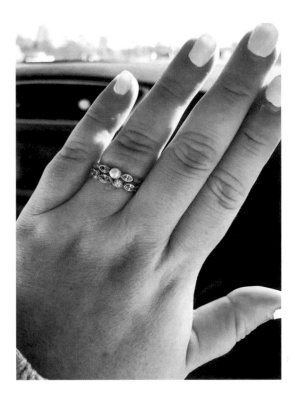

sentiment is wonderful—and I'm not trying to cut down any of your experiences—but when did it come to all that? Why do material possessions equate to love?

My husband was so afraid of me not wanting him because he couldn't afford a piece of jewelry. He was afraid that the love I have for him would pale because he couldn't afford the wedding set I wanted. The world has made it this way, and it is so sad. Ultimately, we couldn't wait any longer, so we eloped. I've never been this happy in my life, and I couldn't imagine spending it with anyone else ever. Here I am, courthouse married, $130 ring set, the love of my life by my side, and happier than I could ever imagine. **—ARIEL McRAE**

IF YOU KNEW ME...

You would know I was nonverbal at two and a half.

You would know I was diagnosed with autism at four.

You would know I got kicked out of two preschools.

You would know I had extreme sensory-integration difficulties.

You would know I would lash out to get attention when I couldn't communicate on my own.

You would know I twirled my hair.

You would know that when I was in school, my peers labeled special education "wrong" instead of "special."

You would know I spent hundreds of hours a year in therapy to get to where I am.

You would know I spent hundreds of hours being bullied because of my diagnosis.

You would know that being institutionalized was a possibility.

But *also* if you knew me . . .

You would know I graduated grade school.

You would know I graduated high school.

You would know I graduated college.

You would know I earned a master's degree.

You would know I have a job.

You would know I consulted for a major motion picture.

You would know I live independently.

You would know I consult to help parents who have children with autism.

You would know I am a national speaker, life coach, and author.

You would know I have had a girlfriend.

You would know I love my family, my friends, and the autism community out there.

You would know that I'm Kerry, and no matter what autism means or doesn't mean, I'm being the best me I can be.

Only if you knew me.

If you are reading this, please know that autism can't define our loved ones, and only we can define autism. I know so many kids on the spectrum today who are trying to be the very best they can be. We as a community have so many unique and beautiful stories to share, so please make sure they are heard. **—KERRY MAGRO**

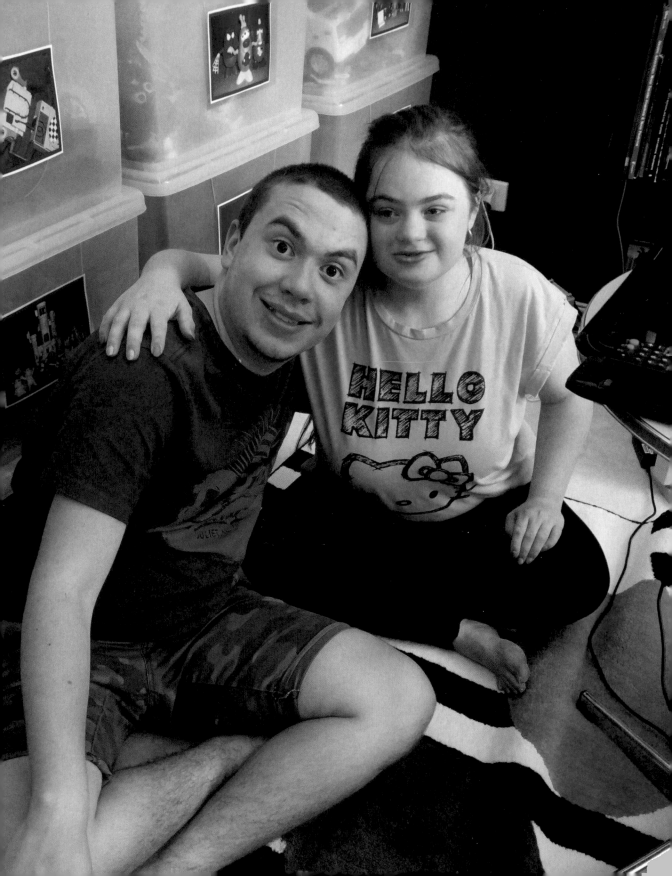

THIS IS MY SON, Nicholas, and his

girlfriend, Jayde. Nicholas is autistic, and Jayde
has Down syndrome. They are both seventeen
years old. Love is love, and having a disability
doesn't stop those feelings. They make each other
happy and love talking and playing with Nick's
Hulk toys. The Hulk is their favorite character. For
Nicholas's eighteenth birthday party this year, he
has requested a superhero–supervillain theme party.
He, of course, will be the Hulk, and Jayde will be
She-Hulk. —LISA JANE FUDGE

WHAT MATTERS
she was gleaming
LOVE

SO, the most amazing thing happened tonight! As many of you know, or may not know, my husband has been very ill. After a yearlong battle and a two-month stay in hospitals, he came home Saturday on hospice. Our daughter, Mikayla, is in the Morton Color Guard and has always wished her dad could see her perform just one time. And his last wish was the same. So with the help of some amazing people, we made it happen!

The Morton High School Marching Band dressed in full uniform for rehearsal tonight. Our entire families were there sitting all together. The band families were there. We had amazing photographers there. The band director made a very special, heartfelt tribute speech honoring Mikayla and her dad and her family as my husband entered the stadium on a stretcher. As his health is declining, the only way to get him there

safely was by ambulance. The Morton High School Marching Band then put on the most amazing show. Mikayla was then escorted to the stands by her guard instructor and her three best friends to see her dad. He had balloons and flowers for her, and we shared the best family hug and moment ever! This made my daughter the happiest I have ever seen her. She was gleaming, she was crying, and it was all amazing!

Words can't express how thankful I am to all who helped make this night so special for my family. Thank you, Jeff Neavor, Erin L'hommedieu Hawks, Jacque Barnes Austin, Kevin Austin, Amie Cassidy, OSF Hospice team, AMT Ambulance Services, and the Morton High School Marching Band and its entire staff. And to our family and friends, we love each and every one of you, and thank you for being a part of our special night! **—NIKKI BANKES**

WE GOT THE CALL on May 17. Could we take

two children, ages seven and eleven, for a few days while a more
"permanent" placement was arranged? Just feed and shelter them
for this short transitional period? Well, we had space, but not
beds. Our boys' room had two vacant bunk beds, but they were
permanently attached, and we needed beds for one boy and one
girl. We agreed to take the seven-year-old boy but reluctantly said
we didn't have a bed for his older sister.

At about seven o'clock in the evening, the Child Protective
Services agent's car pulled into our driveway, and I walked
downstairs to greet this young man. As I approached the car, I
saw a beautiful girl in the front seat. Tears were cascading down
her sweet face. In a flash, I remembered my childhood and times
when life wasn't so perfect. My heart broke for that lovely young
girl, and I struggled to keep my emotions in check.

The CPS worker explained to me that the little boy was
scared and crying, and that I would need help getting him out
of the car and into the house. Do I need to mention that I was
scared too? He was so agitated that for a full forty minutes, he
was climbing over the car seats, pressing all the controls, and
generally acting like a small madman. When we finally got him
out of the car, he took off running down our street. This child
was so terrified that he kicked, screamed, and swore at the man
when he finally caught up to him.

The CPS man picked him up, and we all went inside. The
beautiful young girl, his sister, tried to calm the little boy, even
as she was wiping away her own tears. The boy, meanwhile,
was hitting and kicking the CPS agent, and throwing whatever
he could at the man's head. This was the kind of thing that
had almost discouraged me from fostering. There are so many

children out there who are hurting, and their hurt and frustration compel them to act out in so many ways. I took several deep breaths and asked myself, "What am I doing? What have I gotten myself into? Why? Am I safe in my own home? Is this my calling?" And I answered my own questions.

"Candace," I thought, "this little boy needs you." I could surely provide him a few days and nights of stability. I also have a three-year-old and an eight-month-old, but we could find room in our house and hearts for another child. But I still wished I had a bed for the girl too.

As we tried to settle the little boy so that his sister could be transported to her short-term placement, which was more than a two-hour drive from here, I began to wonder. Finally I said to the CPS agent, "I have an idea! We can cut those bunk beds apart, and these sweet children will be able to stay together!"

Smiling, the CPS agent asked, "Are you serious?"

I said yes. It was just for a few days, but I knew this was the home and the love they needed right now. I felt that God was telling me these children should be with us—we should find a way to keep both siblings.

So my husband and the CPS agent gathered all the tools and materials to separate those bunks. Yes, the CPS man stayed and helped my husband

do this and get the children's rooms set up. The little boy was as overjoyed as any seven-year-old has ever been that we did this for him and his sister to be together. My heart smiled when he looked at me and said thank you and hugged me.

We got through the first night. It was rough, but we got through that one and about four more, when on a Friday I got a call saying that CPS would come for them. They'd found a longer-term placement, but the children would be separated. I sighed over the phone, and my voice trembled. "No," I said. "I can't. They can't be split up." I had seen this little boy so angry and hurt and so scared out of his mind. It was horrible to see. I took a deep breath and asked, "May I keep them?"

"Both of them?"

I said, "Yes! Please, both of them. I want to keep both of them until they go back home."

"Are you sure? Oh my God! You are so amazing, Candace! I can't thank you enough. The things you do for these children are absolutely amazing!"

I cried so hard because I knew I was doing the right thing. We hung up the phone, and the CPS worker called my agency to make sure it was okay with them. She called me back telling me that it was okay.

One week went by. Two weeks went by. We were finally getting a routine down for all four kids and ourselves. Man, oh, man, it's hard work! But I wouldn't change a thing. I know I have said this about five hundred times, but I mean it: the struggles make me stronger, and the changes make me wise. I still have the kids, and they are a part of our family. Every single day, these kids have told me how thankful they are for my husband and me.

They tell us they love us and love being part of our home—that this has been the best foster home they ever were in. (I can tell you, we have heard stories that had my stomach in knots. I never knew such bad foster homes were out there. I've learned that just because you foster, it doesn't mean you're a good person! It really takes a dedicated person to do this right. We have been blessed and overwhelmed with joy doing this for the children who need us the most, but it's not for the faint of heart.)

Not all children stay, and we take them knowing this. It's hard getting so attached and then saying good-bye, but I know we make a positive impact on their lives, and for these short few months, we are blessed to be part of their lives.

This story is a bit different, because we have been able to coparent with the birth mother over the last few weeks, working together for the sake of these children. I will miss them once they leave us to go back to Mom, but they deserve to be reunited. She has been working hard and deserves her babies back. She is a good person, trying and working hard. She tells me every day how blessed her kids are to have my husband and me. She says that she is so thankful for us and for what we're doing for her kids. She said that I have been their mommy, like a second mom to them. You seldom hear these things from a mother who is going through this kind of upheaval with her children. I'm so glad I reached out to her. Not everyone is a bad person. My heart has grown to love so much, and these two children will be a part of my life forever, even when they go back home.

There are happy endings and sad endings, and this, my friends, is a happy one. **—CANDACE WHITED**

STANDING

in line at the post office today, there was a middle-aged worker helping us. Looking at me, he spoke up. "Do you mind if I ask you a question?"

Almost instantly, I knew he was probably about to ask me about my birthmark—as 99.999 percent of questions from total strangers are about that very topic. With a smile, I replied, "Sure."

Then, instead of asking me a question, he told me, "My daughter has the same birthmark as you do. And, actually, so does my niece. I know many people can be unkind with how they react to birthmarks like yours, but just ignore them. You are beautiful."

Dear sir: thank you for your kindness. You're making the world a more beautiful place.

—CRYSTAL HODGES

KRISTA ELIZABETH: I also have a birthmark on my face, and many people have made fun of me for it or made rude comments. I used to be ashamed, but, through the years, I've grown to love it because it makes me different, and sometimes it's better to stand out. We're perfect just the way we are! You're absolutely beautiful, love!

I'VE SPENT the past eighteen years of my life waiting.

I kept my body covered up and hidden away. I told myself that one day I would finally let myself be seen; I would finally do all the things I dreamed of when I was "enough." Thin enough, happy enough, confident enough. When my body looked the way that it was "supposed" to.

I fought my body every step of the way, continually ashamed and silent.

When I was three, my classmates asked why I was so much bigger than them. Why I didn't wear the same smock they did.

When I was seven, I lied to the lady at Weight Watchers, desperate to sit in on meetings full of middle-aged women trying to shed a few pounds.

When I was nine, I went to weight-loss camp and stood in line the first week to take my "before" photo.

When I was eleven, the surgeon cut into my stomach, and he told me how happy I would finally be.

When I was fifteen, I started cutting into my own skin. I thought I deserved it.

When I was twenty, I lost half my body weight in nine months—my worth for the day determined solely by the number on the scale being lower than the day before.

And then I got tired of waiting.

So now I'm twenty-one, and I bought my first bikini. *Ever.*

You can see it all. Weird bulges and rolls of fat. Hanging excess skin. Stretch marks, cellulite, surgical and self-harm scars. An awkward protrusion on my abdomen from my lap band.

I want to learn to love all of myself, not just the parts I've been told are "acceptable." Because the secret is, I was always enough. And you are too. **—LESLEY MILLER**

LAST NIGHT

I found myself in the parking lot of the Essexville Meijer grocery store, on the verge of tears after the milk I'd just placed in my car fell out and splattered all over the ground. Prior to this, I'd managed to pick up a few needed items and some snacks for our low-key New Year's Eve party of four with two very tired boys. Made it through the store, barely escaping a meltdown from the youngest.

Now the milk I needed was puddled on the ground. It doesn't seem like a huge deal until you find yourself with two tired kids buckled in their seats, one crying, parked almost at the end of the parking lot because it's New Year's Eve. Who shops with kids on New Year's Eve? LOL.

Anyway, little did I know that someone was watching me from a car parked across the aisle from us. I placed the cart in the cart return next to that car. A woman got out and said, "I'm so sorry you spilled your milk. I'm a grandma; I know how that is. Please let me go in and get you another one." I said, "No, that's okay." I couldn't possibly make this grandma do that for me. But she insisted. I finally agreed because I knew the boys needed their milk tonight. She told me to wait, and she would be right back.

I waited, and she came back. I offered to pay her. She wouldn't accept it. I begged her to take some money. She wouldn't. She

said, "Happy New Year." I thanked her, gave her a hug, and got into my car. Not only did she get my gallon of milk, but also she bought me an additional gallon and a Meijer gift card! She has no idea what her act of kindness did for me. I was feeling exhausted and defeated for the most part this week, and this stranger's random act of kindness made me cry like a baby.

Thank you to the parking-lot grandma. I hope we can all be a little more like her. I'm hoping the lady who helped me out last night will see this. Please feel free to share. Less hate, more love is my hope. —**KRISTIN SHERMAN**

HARLEE RENEE: She had to make you happy because we're not supposed to cry over spilt milk.
Love this.
Super beautiful.

STEPHANIE EVANS: I read this story to my twelve-year-old daughter earlier today with tears streaming down my face. A few hours later, she, my husband, and I had to make a quick run to the Rite Aid pharmacy. At the checkout were two young girls who looked to be about maybe eight and twelve. When the clerk totaled up their order, they placed their dollar bills and coins on the counter and were 73 cents short. You could see panic in their eyes. I don't even know what they were buying, but I said, "Here, girls, let me help," and gave the cashier a dollar and told the girls to keep the change. As I paid for my own items, my daughter grabbed my face, pulled my head down, and kissed me on the forehead. She turned to her dad and said, "It wasn't milk, but she helped like parking-lot grandma did!" To know my daughter learned something from hearing your story made it even better. Here's to hoping I will watch her pay it forward one day soon also. ❤️❤️

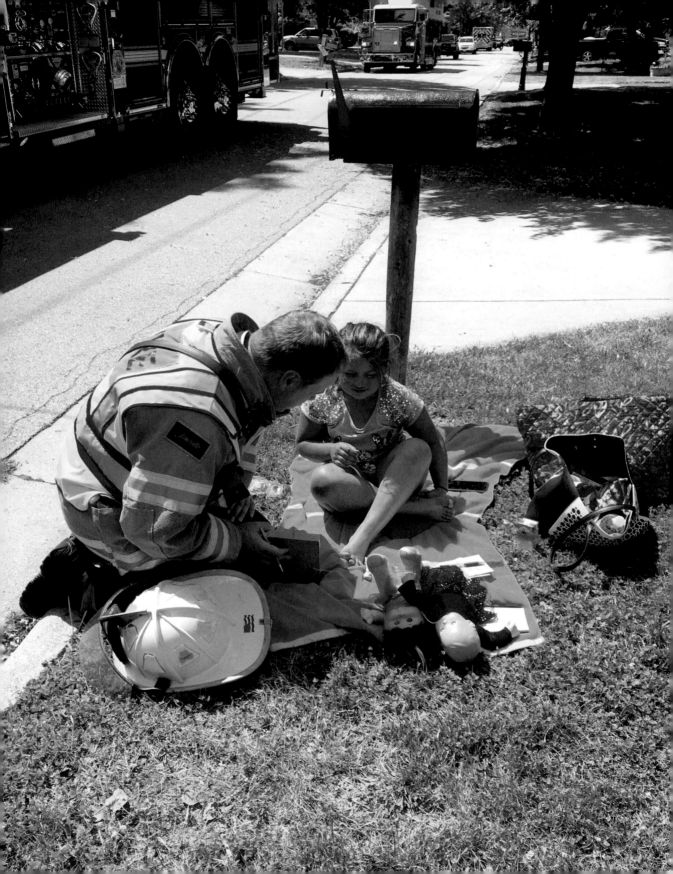

I WANTED to share this picture of a fireman who responded to a house fire at my friend's home last week. This home is shared by a father, two daughters, their grandmother, and an uncle, and they lost everything in the fire. This sweet little girl arrived home with her grandma to find fire trucks and police cars surrounding her home. To keep her busy and distract her from the fire, her grandma set up her blanket with her babies. This sweet, caring, and compassionate man took a few minutes to sit and talk to her and provide whatever comfort he could. —TRICIA TERRY

THIS IS

me at twenty-one years old. This is the day I graduated from the Detroit Police Academy at four o'clock, went home and napped for a couple of hours, woke up at nine thirty that night, and reported to my first tour of duty at the Twelfth Precinct for midnight shift. Look at that smile on my face. I couldn't have been more excited, more proud. Armed with my dad's badge that he wore for twenty-five years on my chest, one of my mom's sergeant stripe patches in my pocket, my lucky two-dollar bill tucked into my bulletproof vest, a gun I was barely old enough to purchase bullets for on my hip, and enough naive courage for a small army, I headed out the door. My mom snapped this photo on the way.

The next seventeen years would bring plenty of shed blood, black eyes, torn ligaments, stab wounds, stitches, funerals, a head injury, permanent and irreparable nerve damage, five ruptured discs, some charming PTSD and depression issues, and a whole lot of heartache. They brought missed Christmases with my family, my absence from friends' birthday get-togethers, pricey concert tickets that were forfeited at the last minute because of a late call, and many sleepless nights.

I've lain in wet grass on the freeway for three hours watching a team of burglars and orchestrating their apprehension. I've dodged gunfire while running down a dark alley in the middle of the night, chasing a shooting suspect. I've argued with women who were too scared to leave their abusive husbands until they realized they had to or they would end up dead. I've peeled a dead, burned baby from the front of my uniform shirt. I've felt the pride of putting handcuffs on a serial rapist. And I've cried on the chest of and kissed the cheek of my dead friend, coworker, and academy classmate even though it was covered in his own dried blood and didn't even look like him from all the bullet holes.

I know what a bullet sounds like when it's whizzing past your ear a few inches away, I know what the sound of a mother's shrill scream is like

when she finds out her son has been killed in the middle of the street, and I know what it's like to have to tell a wife and mother of three that her husband was killed in a car accident while on his way home from work.

Smells, pictures, sounds, and sights are burned and ingrained into our minds—things we can never forget, no matter how hard we try; things that haunt our sleep at night and our thoughts during the day; things we volunteered to deal with so that you don't have to. Things I don't want my sister, little cousins, or *you* to even have to *know* about.

I never once went to work thinking, "I'm gonna beat someone tonight," or, "Hmmm, I think I'm gonna kill someone tonight." I *did*, however, go to work every night knowing that I was going to do the best I could to keep good people safe, even if that meant that I died doing so.

—MERRI McGREGOR

TO THE MOM hiding in her bathroom, needing peace for just one minute, as the tears roll down her cheeks . . .

To the mom who is so tired that she feels like she can't function anymore and would do anything to lie down and get the rest she needs . . .

To the mom sitting in her car, alone, stuffing food in her face because she doesn't want anyone else to see or know she eats that stuff . . .

To the mom crying on the couch after she yelled at her kids for something little and is now feeling guilty and like she is unworthy . . .

To the mom who is trying desperately to put on those old jeans because all she really wants is to look in the mirror and feel good about herself . . .

To the mom who doesn't want to leave the house because life is just too much to handle right now . . .

To the mom who is calling out for pizza again because dinner just didn't happen the way she wanted it to . . .

To the mom who feels alone, whether in a room by herself or standing in a crowd . . .

You are enough.

You are important.

You are worthy.

This is a phase of life for us. This is a really, really hard, challenging, crazy phase of life.

In the end, it will all be worth it. But for now, it's hard. And it's hard for so many of us in many different ways. We don't always talk about it, but it's hard, and it's not just you.

You are enough.

You are doing your best.

Those little eyes that look up at you—they think you are perfect. They think you are more than enough.

Those little hands that reach out to hold you—they think you are the strongest. They think you can conquer the world.

Those little mouths eating the food you gave them—they think that you are the best because their bellies are full.

Those little hearts that reach out to touch yours—they don't want anything more. They just want you.

Because you are enough. You are more than enough, Mama.

You. Are. Amazing.

—BETHANY JACOBS OF *LATCHED AND ATTACHED*

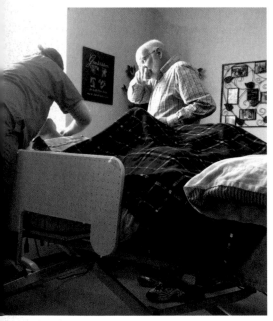

MY MOTHER

was diagnosed with early-onset Alzheimer's disease when she was just fifty-seven. As she slowly declined, my dad told us he wanted to take care of her like she'd taken care of us. He kept her in their home as long as he possibly could. He would get maybe two or three hours of sleep at night making sure she was okay, changing bedsheets, changing her clothes, and washing her, and he never complained. When my mom was moved to a full-time care facility, his devotion never ceased. He visited her every day. He continued to care for her even with the nurses around. He helped lift her, feed her, and wash her, and paid close attention to every detail of her care. For ten years, he did this. No complaints. No resentment. He was gentle, loving, and devoted.

My mother passed away March 22, 2016. My dad was by her side. I am humbled and in awe of what I witnessed. He is a truly special person, and I'm so lucky to call him Dad. **—CHRISTINA JULIAN**

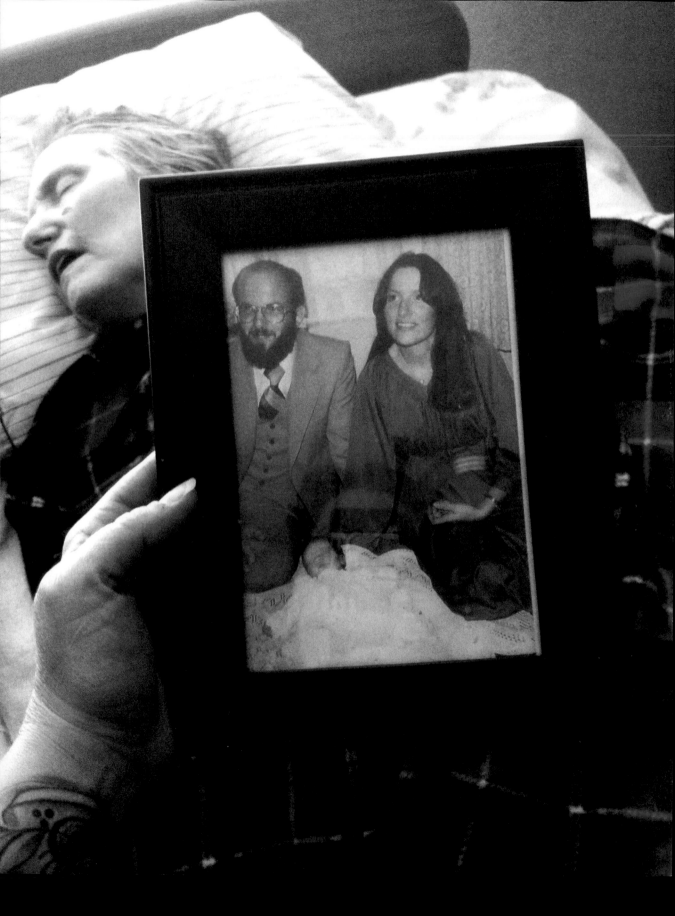

TODAY

I put on a pair of mid-thigh denim shorts, a flowing white blouse, flip-flops, and left the house to run a couple of errands.

Let me pause for a moment to tell you that it took some courage to both purchase and wear said shorts because my legs, while tan from swimming and muscular from dancing, are (1) not where I would like them to be, and (2) are not up to traditional beauty standards (read: Photoshopped) because of cellulite.

My second errand of the morning was a drop-off at the UPS Store. I stood in line between two women. Woman number one in front of me was about sixty. As I took my place in line behind her, she smiled and complimented me on my tan and my hair. We chitchatted about the weather and children until it was her turn at the counter.

In the spirit of paying it forward, I turned to woman number two behind me and smiled. Woman number two was probably about thirty to thirty-five, very attractive, about a size 8, and was wearing a shirt that said "Coexist."

She said, "Your hair really is amazing." Then she cocked her head to the side. "You should probably rethink the shorts, though."

Yeah. Read that again.

My face instantly flushed, not out of embarrassment but anger. No, not anger, *rage*. This, as my head slowly tilted to the side. If you've seen me really angry, you know what I mean.

My fists clenched up. I know this because I felt my nails digging into my palms. So many things ran through my head. Because I didn't have time to get arrested today, what came out was this:

"You should probably rethink your shirt."

I turned around and ignored her until I left the store. I wanted to say more but was afraid, of all things, that I would start crying. All I wanted to do was go home and change my clothes. And *that* made me angry.

Gender doesn't matter.

Race doesn't matter.

Religion doesn't matter.

Sexual orientation doesn't matter.

But fat?

Apparently, fat matters.

And I'll go a step further and say that it especially seems to matter when it comes to actresses. Matters more than talent. Than attitude. Than pretty much anything else. Because fat girls are not believable heroines, ingenues, or objects of sexual desire. But that's a whole other post.

Listen, people, especially women:

Plus-sized doesn't necessarily mean unhealthy.

Plus-sized doesn't necessarily mean lazy.

Plus-sized doesn't mean ugly or undesirable or untalented or uncoordinated or *less than human*.

You might have an issue with my body. I don't. And I've worked very hard to get past judgmental family and friends, past divorce, and past depression to *not* have an issue with my body.

Women, do not tear each other down. Celebrate each other. Every day.

—**BRYNNE HUFFMAN**

STANDING in line at the Hobby Lobby in North Little Rock, I see this: a rainbow heart printed on her belly. I automatically knew what it meant: she had suffered a miscarriage, and now she was carrying a beautiful rainbow baby. As she passed me, I had to speak up. I said, "I love your shirt!" She replied that her husband was hesitant for her to wear it, because people wouldn't know what it meant. I then told her that it's so taboo to talk about miscarriages, and I was proud of her for wearing it. I told her my story, and she told me hers. We hugged and said we would keep each other in our prayers! I, for her baby's continuing good health, and she, for me to conceive. I asked to take a pic and realized that I'd left my phone in the car. She handed me her phone and sent that picture to me. She's such a beautiful woman and mommy! A complete stranger.

Thank you, Autumn, for making my and my husband's day! **—COURTNEY MIXON**

♥ **KATHY VOSHELL BAILEY:** I'd like to get one with the heart over the heart, because I'm a rainbow baby! My mom had several miscarriages after my brother, and I was the miracle baby who was born at six months weighing two pounds and seven ounces—and survived—in 1957!

AND THIS right here, people, is why you should adopt: my niece and her newly adopted dog from a Philadelphia animal shelter of less than two weeks! Talk about being grateful. There are just no words to truly describe the sweetness in this photo. **—JAMIE HOLT**

110 sets of stairs

THIS MAN asked if it was okay for him to climb 110 sets of stairs, fully suited, in honor of his fallen brothers and sisters for 9/11. Yes, sir, you can. I am not one to get emotional, but a few tears were shed. Thank you for your service.

—LEZLIE BAULER

DANI LANIGAN: I climbed 110 flights in full gear in memory of the 343 lives lost. Never forget.

YESTERDAY

Matt was sick. I picked up Archie from the sitter and Eloise from school and decided to run to Target for a few things. I had hoped to be in and out quickly.

I found a line with just one person ahead of me and began organizing my items on the conveyor. After placing my items, I looked up to see that the person ahead of me was an elderly woman. She was paying for her items with change and wanted to purchase each separately. Part of me—the part that had a long day at work, the part of me who had a one-and-a-half-year-old having a meltdown in the cart, the part that had set an unnecessary time line for Target and getting home—was frustrated with this woman and the inconvenience she had placed on me.

But then I watched the young employee with this woman. I watched him help her count her change, ever so tenderly taking it from her shaking hands. I listened to him repeatedly saying, "Yes, ma'am," to her. When she asked if she had enough to buy a reusable bag, he told her she did and went two lines over to get one for her and then repackaged her items. Never once did this employee huff, gruff, or roll his eyes. He was nothing but patient and kind.

As I was watching him, I saw that Eloise was too. She was standing next to the woman, watching the employee count the change. I realized I hadn't been inconvenienced at all: my daughter was instead

witnessing kindness and patience and being taught this valuable lesson by a complete stranger; furthermore, I realized that I too needed a refresher on this lesson.

When the woman was finished, the employee began ringing up my items and thanked me for my patience. I then thanked him for teaching us patience and kindness by his treatment of that elderly woman. And although my time line for Target was askew, when he was finished, I pushed my cart through the store trying to find the manager. I wanted her to know of the employee's kindness and patience, and how much it meant to me. After tracking her down and sharing the story with her, we left Target with a cart full of consumable items, but what is more, hearts full of gratitude for such an invaluable lesson.

If you are ever in the Glendale, Indiana, Target, give Ishmael a smile and a nod. The world could use more people like him. **—SARAH BIGLER**

CHERILYN WOOD: This made my heart swell with pride and made me cry tears of happiness. My eighty-five-year-old mother could have been that woman. I worry about my mom more every day as things become harder and harder for her to do. I get embarrassed when she holds up the checkout lines when we go out shopping together; when her arthritis and crooked, numb fingers make it take her so long to pay, because she will never be one to swipe a credit card. This young man is a saint. May he teach many others the same lesson of patience. Thanks to Love What Matters for posting this!

MY SON

was born with congenital hypothyroidism and wasn't breathing. His father left me when I was four weeks pregnant with him. I started talking to another man as my due date neared. My son was born January 27, 2015. Travis was that man. He sat through four months of continued hospital stays and a sick, screaming baby. He helped me emotionally and let me rest and watched over my son.

My son is now one, and Travis hasn't left. He still sits at every hospital visit and every doctor's appointment and surgery. He lights my son's world on fire. To this day, my son jumps for joy, clapping and giggling, every time his daddy gets home from work. Travis has sacrificed and stepped up, when it wasn't his job. Travis has showed me how to love again and showed my son real love. He has been the best father figure ever.

—DARION GUDEMAN

♥ **JODI BOWMAN:** A daddy is not who makes the baby but who raises the baby. Glad you found that daddy for your beautiful boy. xx

IN THE LAST forty-eight hours, he has worked thirty-two hours, spent two hours getting ready for work, and three and a half hours driving to and from work. That's thirty-seven and a half hours in just two days that he's dedicated to work. That's almost a full workweek in two days.

When he comes home, he still finds time to sit down and watch Netflix with me, change a diaper or two, play with the animals, and be completely supportive of everything I need and want to do. He still has the time and energy to be my absolute best friend.

He's gotten less than five hours of sleep a day for at least three days now and is spending his first Father's Day sleeping so that he can go back to work later today for a twelve-hour shift.

I couldn't ask for a better role model for our daughter. He is an amazing example of what hard work is and what we do for those we love. **—CHANTAL ST. PETER**

TODAY

I got to reunite with one of the oncologists who saved my life when I had leukemia as a small child. She's been taking care of me since I was one year old, and seeing her today at the Children's Hospital of Pittsburgh was so surreal. The hug is actually a candid photo; not planned at all. I yelled her name through a set of double doors, and we both ran to each other, embraced, and shed tears. I can't wait to save lives the way she saved mine. I'm forever thankful for her amazing work that she put in to make sure I could still be alive today and practicing in the medical field! **—DIANA DeBERNARDIS**

AFTER WORK I went to the store to pick up a few things.

While I was checking out, the cashier looked at my name tag and asked, "So what do you do there?"

I replied, "I'm a nurse."

She continued, "I'm surprised they let you work there like that. What do your patients think about your hair?"

She then proceeded to ask the elderly lady in line behind me, "What do you think about her hair?"

The kind older lady said, "Nothing against you, honey, it's just not for me."

Then the cashier continued to comment that they didn't allow that sort of thing even when she worked fast food, and that she was shocked that a nursing facility would allow that.

Well, here are my thoughts: I can't recall a time that my hair color has prevented me from providing lifesaving treatment to one of my patients. My tattoos have never kept them from holding my hand as they lay frightened and crying because Alzheimer's disease has stolen their minds. My multiple ear piercings have never interfered with me hearing them reminisce about their better days or listening to them as they express their last wishes. My tongue piercing has never kept me from speaking words of encouragement to a newly diagnosed patient or from comforting a family that is grieving.

So please explain to me how my appearance, while being paired with my cheerful disposition, servant's heart, and smiling face, has made me unfit to provide nursing care and unable to do my job! **—MARY WALLS PENNEY**

we aren't invincible

NINE MONTHS out of the womb. In the last nine

months, I have never slept so little in my life. In the last
nine months, I have suffered the worst anxiety I have ever
experienced. Having a new baby is exhausting, and life just
doesn't stop. The bills still need to be paid, groceries still
need to be purchased, and the pressure you put on yourself is
overwhelming. We expect ourselves to know what we're doing
all the time. It doesn't matter if it's your first or if it's your third,
you're still learning daily. The first nine months of your baby's
life are filled with guessing, rocking, smiling, and crying. The
amount of pressure we put on ourselves isn't fair. We aren't
invincible. We're humans, and we're mothers. It's okay to have
days when you don't feel good enough. It's okay to feel like you
have no idea what day it is. You've got this. We've got this. Some
women seem to have it all—well, so we think. Some women
don't. I don't. I didn't have the motivation to even get dressed
for the first nine months, let alone get my pre-baby body back.
And that's okay. If you do have the motivation, good on you! Life
challenges us daily. We are given new obstacles every single day.
There's always tomorrow! **—MEL WATTS**

LISA SILVA FLECCHIA: Sending a virtual
hug! Motherhood is a constant struggle,
but it gets better. It's a juggling act, and
some days are better than others! Enjoy
your baby and try to rest when he rests.
That's a tip I didn't heed until baby number
two. Everything else will get done sooner or
later. Don't be afraid to ask for help if you
need it. Try not to be so hard on yourself.
It's true what they say: "Enjoy every
moment, because it goes by so fast!"

THERE are ninety-two years between these two hands. One has seen the world, with nearly a hundred years of hard work etched into wrinkles and folds. The other is just barely formed, knowing only the softness of a belly and a blanket. Yet here they are. Two hands with so much to tell that nobody else could begin to imagine. A great-grandfather and our youngest baby! One life is nearing its end, while the other is just beginning. **—CIPRIANA GREEK**

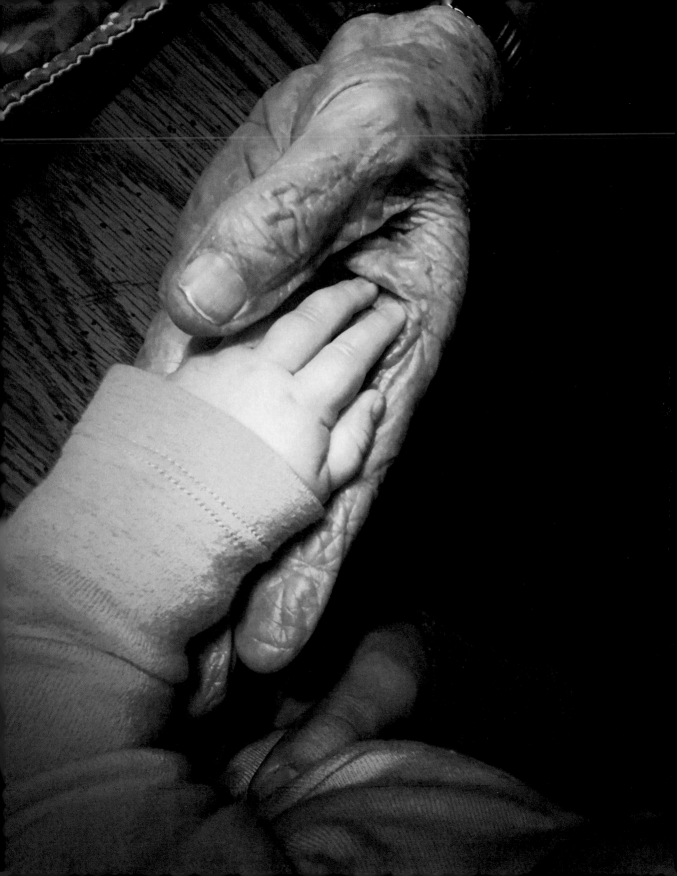

mommy was strong

"**MOMMY,** do you want to be skinny?"

My eight-year-old daughter asked me this, and it brought me to a complete halt.

It caught me off guard, as I have never said I wanted "to be skinny." But I wasn't completely surprised she asked, as she does see me work out and talk about nutrition, not to mention that my husband also works in the wellness field.

As I looked at her staring intently back at me, I knew exactly what I wanted to say, as I am raising three young daughters whom I'm trying to mold—three daughters whom I never want to have a body complex, or feel inadequate, or compare themselves with someone else, thinking they need to have "her body."

But . . .

I want my girls to value their health. I want them to respect their bodies and ensure that they remain respected by others.

I want my daughters to keep their health a focus and a priority throughout their lives, continually working on becoming the best versions of themselves physically, emotionally, and spiritually.

You see, my children are never going to remember how many push-ups I was able to do. They won't remember how fast I was able to run a 5K, nor will they remember what size I was—or wasn't, for that matter.

But they *will* remember that their mommy was strong. That she was fierce. That she believed in herself

when nobody else did. And despite all the times things got tough—insanely tough—and despite all the times it would have been easier to quit, my children will remember that was when Mommy pushed harder.

I want my children to look back and say, "Because of my mommy, I never gave up."

So without hesitation, I leaned down and looked confidently into my young daughter's eyes.

"So, Mommy . . . do you?"

"No, honey. Mommy wants to be strong!"

And with that, she hugged me and whispered as she was pressed against my chest, "Then I want to be strong too." **—REGAN LONG**

MY HUSBAND

decided that once a month he will take our little girl out on a "date," where she gets all dressed up and gets taken out for cake and ice cream. Tonight was their first night doing it. He helped her pick out a dress to wear, got a little purse ready for her, held the door open for her, and made her feel like a princess. She loved it and was so happy when she got home. She will always know how she deserves to be treated because her dad sets such a high standard. **—CAITLIN FLADAGER**

KESLEY POSEY: I don't want to take away from how sweet this is—it is special and sweet, and I love that he does this. But can I offer something to consider? I've not been on a date where I was treated poorly. Sure, a man might miss a door here or there, but generally men have their best foot forward on a date.

Fathers: show her how a man should be in her home. (Definitely take her on cute dates, but that's the easy stuff.)

Show her that men should share in cleaning the kitchen. Show her that a man is respectful toward all women, even if she holds a different opinion than the one he holds. Show her that a man should clean up after himself. Show her that a man seeks his education and betters himself. Show her that a man is encouraging at the end of a tough day and patient when she needs it. Show her that a real man understands things such as moderation and self-control.

I'm sure this sweet daddy does these things too, but just a point of perspective. It's easy to find a good date; much harder to find a good partner.

PHOEBE STRATTON: My son and I have "date nights." We take turns planning our dates. Sometimes it is as simple as putting on pj's and watching a movie or going for dinner and a movie. Now that he earns money from chores, he insists on paying for at least one thing. He said it makes him proud that he can take care of me, LOL.

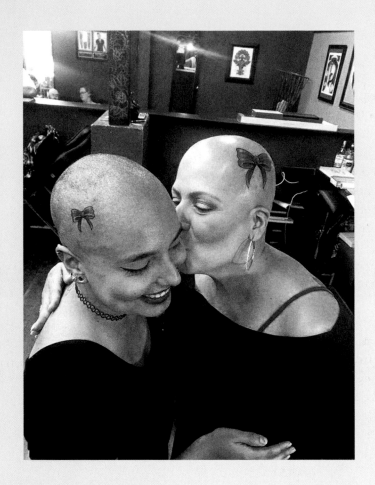

MY FRIEND
Veronica had her last day of treatment for cancer. Her daughter shaved her head in support, and they both got matching tattoos. The bond between mother and daughter is so beautiful. This is what true love looks like! **—DEBI UNGER**

miraculous serendipity

FOR EIGHT YEARS, I have struggled not to
let myself be defined by infertility. It's hard not to, especially
when my abdomen is covered in scars from the surgeries and
procedures. Our most recent in vitro fertilization pregnancy
ended in the second trimester, and it was devastating. I knew I
needed a positive physical reminder, and I chose a tattoo of baby
footprints on my forearm. The tattoo artist suggested making the
feet a little larger, and I hesitantly allowed him to.

Seeing the tattoo on my arm
every day has lifted the weight of
grief just enough to keep going.

Out of curiosity, I looked up the
size of my unborn baby's feet at the
time he died. Then I measured my
tattoo, just to see how close in size
it was. The tattoo is the exact same
size as his feet. It was a miraculous
serendipity, and I love it.

It reminds me that in the face
of loss, there is always hope.

—JENNA WOESTMAN

TO THE MOM in the baby water park at Kentucky

Kingdom yesterday, I talked to you about your kids. Their behavior struck me in such a way that I did something I normally don't do, and I asked your son where his mother was so I could have a word with her. We spoke, and I don't think you fully understood how your children and their behavior affected me, so I am writing this. Maybe it will find its way to you, and you will know who you are. Maybe it won't, but other moms will see it and maybe take away something from it as well. It may not seem like a big deal to other people. But I do know that there are some people who will really get it.

I was at the park with Baylee, my five-year-old. She is autistic and mostly nonverbal. We were practicing very hard on waiting in line, and she was doing well, for the most part. We had a routine: wait in line; then when we were four from the front, sit on the step; then down into the water; then scoot up; and then wait at the top of the slide for the okay to go from the lifeguard. Every time she did it, her understanding of the routine improved and her patience increased. But, alas, children are children: there are little ones who don't understand waiting and jump right in front of the next in line. For the most part, this is no big deal, but not for a kiddo like mine, who really doesn't mind much that she had to wait longer but is very upset that the steps of the routine she just learned are now out of whack. And to her it feels like the end of the world! Coping with unexpected change is another skill we practice every day. It is one of the more difficult skills to practice, especially in

public when people—particularly other children—do not understand why she is reacting the way she does. I dread it. Not what she will do but what other people will.

So this happened, and as she was expecting to move up to the next step in the waiting game, and then couldn't, I braced myself for what would happen. That is when your daughter looked up at me and said, "She can go ahead of me." Baylee had not had an opportunity to get upset yet, so I am not sure exactly why she did it. I felt like maybe she could tell by the way I had been talking to my daughter that she had special needs. It was so sweet, and I told her what a sweet girl she was. And we moved on. Of course, as busy as the park is, it wasn't long before we found ourselves in the same situation. This time a young boy was in front of us, and he offered to let Baylee go ahead because he could tell she was not understanding what happened. Again, I praised his good behavior and kindness, and we went ahead. I was struck that two different children would be so intuitive and kind. Like most autistic children, Baylee does not *look* any different from any other child. And it's not really immediately obvious by her behavior, either. It takes some observation, and usually children their age don't realize she has autism. I guessed them to be between eight and ten or so.

When I then saw them together, it made sense: they were brother and sister. I told them both how great it was that they looked out for someone who was different and the difference that small acts of kindness make even if it doesn't seem like much. They really touched my heart.

So I asked your son to point you out. I wanted *you* to know that you are raising two wonderful children. When I

came to you and told you about my experience with your kids and told you that they were super kids and that you are doing a great job, you said, "I don't know about that." Well, Mom, you are. A small gesture like theirs might not seem like much. But I promise it was.

As a mom of a child with autism, we do not know what to expect for Baylee. She grows and learns more every day, but I still worry. Every time she has a big improvement or meets a goal she has worked for, my joy is immediately dimmed by the concern I have for the kinds of struggles she faces in a world that is not always kind. She is so funny and smart, and she brings a smile to the faces of most people she comes into contact with, but sometimes we encounter people who do not immediately see how sweet and funny she is. I know there are people out there who will refuse to see those things simply because she is different. It scares me. I worry, I dread, and sometimes we stay home because we don't want to deal with some of the unpleasant things we experience sometimes.

Sure, your children's kindness helped in that moment to avoid a meltdown, and that is kind of a big deal for kids on the spectrum, but I will tell you what is an even bigger deal, though, and that is that it gave me some *hope*! When I looked at those sweet little faces, filled with pride as I praised them, it made me happy to know that more moms are raising their children the way you are!

So I just wanted to take the opportunity again to thank you and let you know you are doing a really, really good job!

—STEPHANIE SKAGGS

secret language of the cookie

WHEN my daughter gets off the bus, embarrassed and in tears, as a mother, it is considered "normal" for me to want to protect her and come to her defense. Although, I am a woman who is led by the Holy Spirit, and peace, love, and grace are what invade my heart.

Lexi (who is fourteen years old) explained to me how the bus driver stopped the bus in the middle of her route and yelled at her for ten minutes in front of all the kids because she was sitting on her knees and braiding her friend's hair. (Apparently, sitting on her knees is what infuriated the bus driver.)

The angry woman kept tearing Lexi down with words, and her delivery was completely uncalled for.

After Lexi calmed down and we talked it through, I asked my daughter a question: "Lexi, want to do something radical?"

"Sure!" Lexi replied.

"How about you respond to your bus driver in *love*, because she clearly is lacking it! All she knows is anger and frustration. How about tomorrow morning you present her with freshly baked cookies and a hug!

"You and I both know that she doesn't 'deserve' it. If anything, she owes you an apology. But after all, isn't that what *grace* is all about?"

My precious daughter quickly replied, "Can we bake the cookies now?"

That next morning, when Lexi handed her bus driver those cookies, the woman sat there in disbelief because she knew in her heart of hearts that she'd overreacted in pure anger and foolishness. Yet Lexi humbly came to her in love.

Trust me when I say those cookies spoke a million words in Lexi's defense!

The bus driver asked Lexi, "Can I have a hug too?" And just like that, *peace* entered in! **—HOLLY WRIGHT**

BEST BIRTHDAY present ever when your best friend comes from China to the US to be with his new family!

For those unfamiliar, when we were adopting Hannah from China, we would receive pictures of her. In many of the pics, there was this cute little boy holding her hand or playing alongside her. People who had visited her orphanage told us about them playing together. When our agency visited the orphanage and met with the children, they walked in hand in hand. When we were in China and toured her orphanage, Hannah became so excited when she saw Dawson. They hugged and laughed, just like they do here. It was obvious they were fast friends.

So we posted pics of Dawson and said, "This boy needs a family!" Well, our church friend Amy Garland Simmons happened to be at Chick-fil-A for their Preschool Spirit Night. They were looking at our FB photos of us in China when Amy Stanley Clary and Christopher L. Clary walked in. Amy showed them Dawson's picture and said something to the effect of "Y'all should adopt him." Chris told me that in the time it took to take the kids to the play area and come back, the decision was made to adopt this sweet boy. And he responded, "Well, I've always wanted to go to China!" Eleven months later, they have brought him home!

Y'all, this is such a God thing and an answer to prayer. The right people, in the right place, at the right time—a miracle. When we left Dawson in that orphanage, my heart hurt knowing he didn't have a family. I couldn't stop thinking about him. Amy and I started messaging about him while we were still in China. We'd had Hannah with us only two or three days. We are so grateful to the Clarys for giving Dawson a forever home! They live five minutes from us, and we have become good friends. And, who knows, one day we may be in-laws. **—SHARON CUTCHER SYKES**

DEAR Woman in Target:

I've heard it before, you know. That I "spoil that baby." You were convinced that she'd never learn to be "independent." I smiled at you, kissed her head, and continued my shopping.

If only you knew what I know.

If only you knew how she spent the first ten months of her life utterly alone inside a sterile metal crib, with nothing to comfort her other than sucking her fingers.

If only you knew what her face looked like the moment her orphanage caregiver handed her to me to cradle for the very first time: fleeting moments of serenity commingled with sheer terror. No one had ever held her that way before, and she had no idea what she was supposed to do.

If only you knew that she would lie in her crib after waking and never cry—because up until now, no one would respond.

If only you knew that anxiety was a standard part of her day, along with banging her head on her crib rails and rocking herself for sensory input and comfort.

If only you knew that the baby in the carrier is heartbreakingly "independent"—and how we will spend minutes, hours, days, weeks, months, and years trying to override the part of her brain that screams "Trauma" and "Not safe."

If only you knew what I know.

If only you knew that this baby now whimpers when she's put down instead of when she is picked up.

If only you knew that this baby "sings" at the top of her lungs in the mornings and after her nap, because she knows that her chatter will bring someone to lift her out of her crib and change her diaper.

If only you knew that this baby rocks to sleep in her mama's or her papa's arms instead of rocking herself.

If only you knew that this baby made everyone cry the day she reached out for comfort, totally unprompted.

If only you knew what I know.

"Spoiling that baby" is the most important job I will ever have, and it is a privilege. I will carry her for a little while longer—or as long as she'll let me—because she is learning that she is safe. That she belongs. That she is loved.

If only you knew. **—KELLY DIRKES**

I WAS FEELING pretty jaded this morning

as two different sets of parents at Walmart stopped me in the school supplies aisle to complain about how much they had to buy their kids this year. "This is just ridiculous. I don't know how these teachers think we are supposed to get all this stuff."

As they complained, they seemed oblivious to the fact that my cart was filled with a class set of all the supplies they were buying—which should have been a pretty clear indication that I was one of those greedy teachers they were complaining about. While I was checking out, though, things took a very different turn. I noticed the man in front of me in the checkout lane was buying school supplies for his daughter. As he went to leave, he said to me, "You are a teacher, right? I just want to thank you for everything you do. I see your cart is full with supplies, and I just wanted to help out as much as I can." Then he handed me a $25 Walmart gift card, shook my hand, and walked away with his daughter smiling big at me.

While I was extremely moved by the man's generosity, the part that stuck with me the most was the difference in his message to his daughter compared with the parents who had been complaining earlier.

The kids who heard their parents complaining received this message: "School is not important enough

to spend money on it, teachers are not to be trusted and have bad judgment, and learning does not require investment."

The kid whose dad handed me the gift card heard: "School is important enough that we should give more than required to make sure it is successful, teachers should be respected and valued, and learning requires us giving it everything we have."

If money is tight, and you struggle to buy your child school supplies, I understand. Don't worry: more than likely, your child will have a teacher and a school that make sure he or she has the necessary supplies for a successful year. However, as a parent, do your best to send the right message to your child. The man who gave me the gift card not only made my day, but I also know that his daughter will enter the classroom this year with a very different perspective about her teacher and her education, and that is extremely powerful!

—LELAND SCHIPPER

YESTERDAY

my wife, Debbie, and I had a huge scare. She handed me her ring so she could put on sunscreen lotion. I slipped it into the back pocket of her shorts and thought she heard me say I did. We went through our day at the beach, and, as we were leaving, she asked me for her ring. I told her I'd put it in her shorts. It wasn't there. We took turns looking on the beach and couldn't find it.

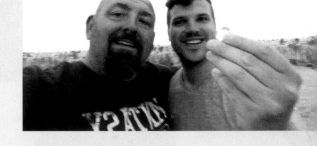

I took to Facebook groups as a Hail Mary, posting on ten different Long Island Facebook pages. There were so many people sharing our post, commenting, and showing their compassion. A few people with metal detectors reached out to me. One guy, Mike Jandris, wrote that he was getting in his car and would be there in thirty-five minutes. This blew my

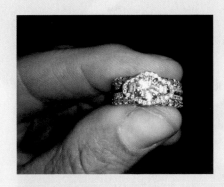

mind: this guy, who had never met me or my wife, was willing to help us find her ring, let alone drive out of his way to help. I met him down there, and within five minutes of us looking at the spot with his metal detector, he found it. He truly is a hero to me and my wife. I told him to please add me on Facebook because only a true friend would drive out of his way to help someone find a ring! Thank you again, Mike! —**BRANDON POTTER**

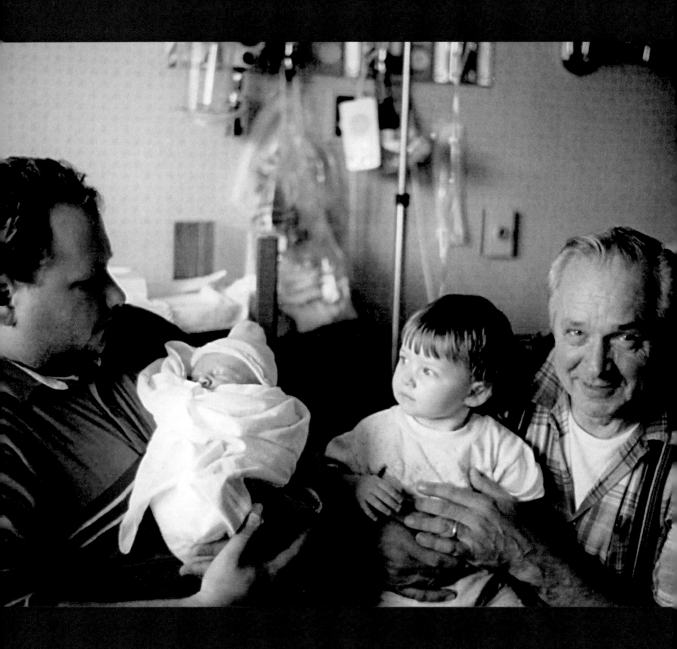

dad is still teaching me

TODAY I had a memory come to me: my father had a pickup truck that he loved. He had purchased it used, drove it on his land, and would run it all over town. It was a bucket of bolts, but he loved it. He was driving on the highway into town one morning when the steering wheel came off in his hands. I was horrified when he described this event to me a few days after it happened and asked how he'd reattached the steering wheel while on a highway, as I knew he had survived unscathed and his truck had no new dents.

He laughed at me and explained that once that steering wheel had come off, it was no longer of any use. So he threw it aside and stuck his hands into the steering column to guide the truck. I think we all know that I would have wound up on the side of the road in a mangled mess had this happened to me.

The point of the story is that we all have something to which we cling that we feel is in control of or steering our lives, but it gives only the illusion of control. When faced with hardship, some will cling to this thing until the bitter end. Others will throw up their hands and pray for answers. The wise few will focus on the true control and reach inside. Thanks, Dad, for sending me this memory today to remind me that I need to cast aside those things that give only the illusion of control and comfort. I need to reach within myself to guide my life on the path I choose. I have the real control.

Even almost twenty-three years after his death, Dad is still teaching me. I am in awe, and very grateful.

—STEFANIE HELMS POWELL

good boy, Jedi

THIS MAY just look like a dog, a sleeping boy, and a number on a screen, but this—this moment right here—is so much more. This is a picture of Jedi saving his boy.

Five minutes before I took this picture, we were all asleep. No alarms were going off, no one was checking blood, no one was thinking about diabetes, and it's in those moments when our guards are down—when we are just living life, when we let our minds drift from diabetes—that it has the upper hand, and things can get scary very fast. But, thankfully, we have a Jedi.

Jedi jumped off the bed and then back on again. Though I felt him do this, I didn't wake up. Then Jedi lay on me. I woke up. He jumped off the bed and then half on, and would not budge when I told him to get back up. I got out of bed; he bowed. (Bowing is his low alert.) Luke's monitoring device said his blood sugar was 100 steady. So I told Jedi that we would watch and see. He bowed again. I told him to get up on the bed, but he held his ground and refused to budge. Then I knew he meant business. The sleepy fog started to wear off, and I began to think more clearly. I suddenly was fully awake, and I knew there was an issue. I tested and got 57—way too low—and by Jedi's behavior, I guarantee that Luke's glucose level was dropping fast. (He was still recovering from a stomach bug, so anything under 70 was low.)

Luke was lying right next to me—just inches from me—but without Jedi, I wouldn't have had any idea of what was happening to him. He has never woken up on his own for a low level in more than four and a half years. We are his safety net. He goes to bed every night, and although he doesn't know it, he relies 100 percent on us to keep him safe overnight. That's why

we check him overnight every night, and we have every tool, every monitor, and have spent every day of the last three years training Jedi to alert us to highs and lows, because type 1 diabetes is relentless, and we need as much help as we can get.

This is a picture of Jedi saving his boy. Amidst a disease that does everything in its power to make life so much harder, this is a picture of loyalty and love and perseverance. A reminder that we

good boy, Jedi

will not let diabetes win, that we will never give up, and that we will always fight for our children.

Good boy, Jedi. Yes, it's time for a late-night puppy party.

I had already given Luke a glucose tab to raise his blood sugar before I took this picture; there was nothing else I could do. So I took one second to take this quick picture, because in that moment while you're waiting for your child's blood sugar to come up—like you've done thousands of times before, and you'll do thousands of times again—it's very easy to feel alone in a world that doesn't understand everything that somebody with type 1 diabetes goes through on a daily basis. So in that moment, I decided I would take a picture so I could share this story later, because if we don't share our stories, how will anybody ever know that this is what my son and millions of others go through every single day? Most people don't know that we often see multiple lows and highs every single day, no matter how hard we work or how diligent we are. It's not easy trying to "be" a pancreas. We need awareness about a disease that most of the world doesn't understand, and we need to help show the world why we so desperately need a cure. **—ADORA NUTTALL**

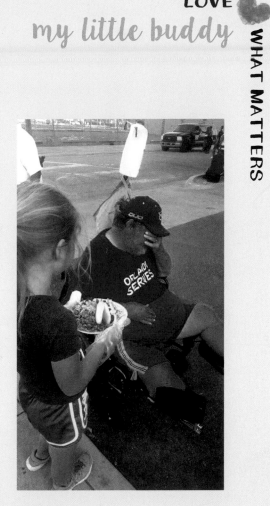

HE SERVED our country.
He is a veteran. He is disabled. And he is homeless. He has been living on the streets. The shelters won't take him in because he can't care for himself. He is hurt. He is without hope.

We had the honor to pray with him today. To ask him about his life. To hear the hopelessness in his voice was heartbreaking. Since this picture, Julianna has visited him daily. He calls her "my little buddy" and looks forward to seeing her and has asked to come to church with us. Hope is coming back into his voice. The power of kindness and love to a stranger is being lived out before our very eyes.

—JENNIFER CAMPOS

OUR BOYS wanted to take their longboard skateboards with them to Florida, so we asked the skycap this morning whether they needed to be checked or could be carried on. He said they were fine to carry on, but we were still nervous they wouldn't allow them. They stowed them in a coat closet for us on the first leg of the flight, due to their size, so we thought we were good.

When my wife got to the airport in Phoenix for her connecting flight, however, the pilot walked up to our sons and said, "I'm sorry, boys, but those boards need to be inspected to ensure they are safe for the flight." Then he asked if he could see the first one, and to our boys' surprise, he rode it all the way down the Jetway. He walked back up with the first board and said, "Okay, now the other one." Then he grabbed that one and rode it down the Jetway. He walked back up and said, "Okay, boys, these are now pilot approved—enjoy your flight!" **—RYAN WILDEN**

I SAT in Tim Hortons with my daughter, as I do often. Two ladies sitting near us started to stare and whisper. This is a pretty frequent occurrence for us, you see, because Sophia was born with Down syndrome. I sat there and watched these two women crane their necks to get a better look at her, completely oblivious to the fact that I was staring right back. This day it bothered me. It really bothered me.

Just then, a couple approached me, and I thought, "Oh great! More people who want to take a closer look!"

The man greeted Sophia with a high five and a handshake, and Sophia smiled and waved back. He looked at me with tears in his eyes and said, "I have a story I would really like to share with you. But I am afraid I won't get through it without choking up." I gently encouraged him to share, because now I was curious. This interaction was not what I was expecting.

He told me that he had watched the news the night before. There was an interview of a mother who had recently given birth to a child with a major disability. She was on the news defending her decision to keep her baby. She was defending her choice *not* to terminate despite her doctors' encouraging her to do so. He said, "The point is, you never know a person's impact on the world. You can never know what a person is able to do unless you give them a chance." He looked at

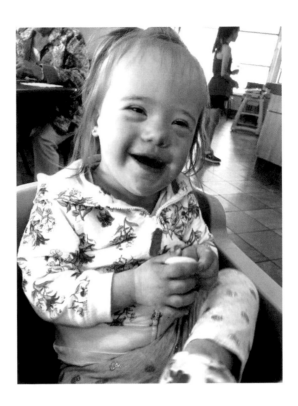

me just before he turned to walk away and said, "You are a beautiful person. Your daughter is beautiful. Congratulations!"

I immediately started to cry. There I sat in the middle of a coffee shop crying into a paper napkin. That man was the first complete stranger ever to congratulate me on the birth of my daughter, Sophia. He was the first complete stranger to recognize her *worth*. Her *value*. Her *beauty*.

In a world where my daughter's life is whispered about, where she is stared at, this man saw her *importance*. **—PAMELA DE ALMEIDA**

235

I SNAPPED THIS PICTURE the other night

at the end of a long day. I was tired. I was irritated. I had sent my husband a text telling him that I knew it wouldn't make a difference, but I wanted him to know that I was feeling fed up with how much he works and with all that I have to do every day by myself. The full-time job, cooking dinner, bathing kids, weekend trips without him, keeping up a home—you name it, I was resenting it. I have to have these little moments once (okay, several times) throughout planting and harvest season.

Then this happened: he came in, fixed his plate, and sat down to eat all alone. He was tired. He was hot. He was exhausted. Rather than complain, he said he was sorry I was tired and felt that way. Charlotte joined him and talked his head off, and even ate most of his dinner. He didn't complain. He shared, and it hit me: Do I wish that we saw him more than an hour or so a day? Yes. But the love he has for his craft is something to envy.

Farmers work in a thankless profession. It's always non-GMO this and organic that, and let's not even talk about the stress from Mother Nature. This is a man who is working to uphold four generations of blood, sweat, and tears, and showing his children the value of hard work and discipline. So while I felt frustrated, I really should have felt thankful: I got to sit down to dinner and hear all the stories from the day with the kids. I got to give them baths and hear their squeals and giggles. I got to snuggle and love on them for three hours more than he did. He is the one sacrificing, not me. We will keep on keeping on until the next rainy day, when we get a few extra hours with our hard worker. In the meantime, the next time you slip into that comfy cotton shirt or eat delicious farm-fresh food, thank a farmer. Where would we be without them? **—KATIE PUGH**

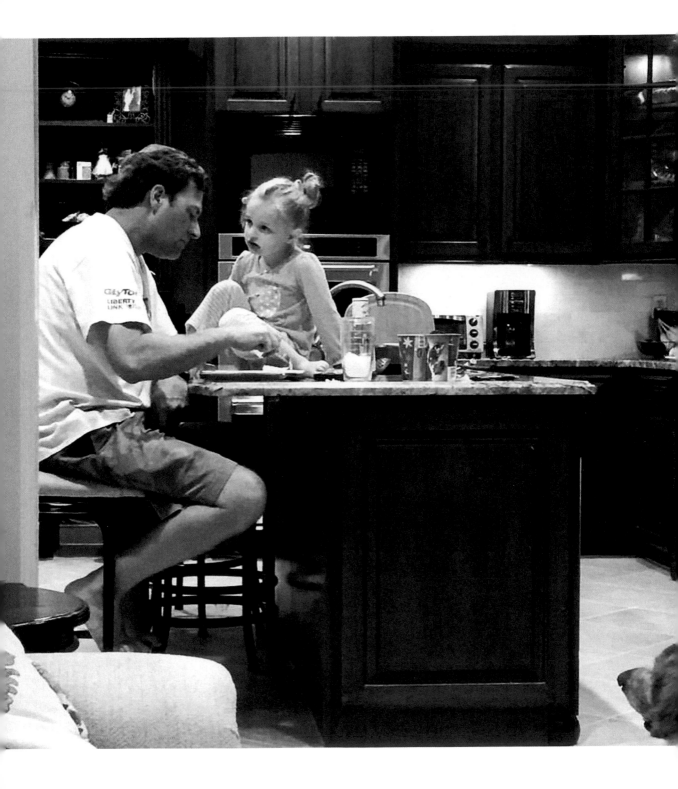

THIS

THIS was from several weeks back. Yes, I climbed in the crib in hopes of soothing my screaming, teething, blushed-faced, and tear-soaked little girl. My husband came home to this, and I am reposting because it captures the essence of my heart and my "why." There I was in the heat of this exhausting, beautiful thing we call parenthood, and I remembered a promise I made to her.

One of the first times that Matt and I left Luella was to attend a worship concert. At that event, a missionary shared his story, and it shook me to the core. It was a moment that would be burned forever in my fragile, hormone-raging, new-mommy heart that had already become a hundred times more fragile after meeting my baby.

That missionary had visited an orphanage in Uganda. He has been in many before, but this one was different. He walked into a nursery with more than a hundred filled cribs with babes. He listened in amazement and wonder as the only sound he could hear was silence. A sound that is beyond rare in *any* nursery, let alone a nursery where over a hundred new babes lay. He turned to his host and asked her why the nursery was silent. Her response was something I will never, ever forget. *Ever.* This was my "why" moment.

She looked at him and said, "After about a week of them being here and crying out for countless hours, they eventually stop when they realize no one is coming for them."

They stop crying when they realize no one is coming for them. Not in ten minutes, not in four hours, and maybe, perhaps, not ever.

I broke. I literally could have picked up pieces of my heart scattered about the auditorium floor. But instead, it stirred in me a longing. A hunger. A promise in my spirit.

We came home, and that night as Luella rested her tiny little ten-pound body against mine and we rocked, I made a promise to her. A promise that I would always come to her.

Always.

At two in the morning, when pitiful, desperate squeals come through a baby monitor, I will come to her.

Her first hurt, her first heartbreak, we will come to her. We will be there to hold her, to let her feel and to make decisions on her own. We will show her through our tears and frustrations at times that it is okay to cry, and it's okay to feel. That we will always be a safe place, and we will always come to her. **—DAYNA MAGER**

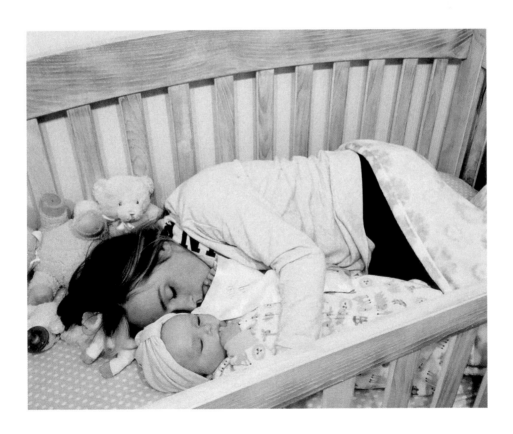

IT TOOK his left-behind toothbrush to undo me.

I'm sitting here in a parking lot sobbing my guts out. He was mine for two and a half weeks, but those days and nights saw him smile, sleep through the night instead of freezing awake in terror, swing for hours on the swings my kids take for granted. He called me Mama, and I told him every time I left that if I said I would come back, I would. I prepared him for his new home as well as I could, but now it's nap time, and his new mom says he misses me. I texted her a picture to show him.

The number one thing people say to me is: "I could never do foster care. I would get too attached." Guess what: I'm just like you. I got attached. I was the only one who could get him to sleep or knew exactly what kind of jam he liked on his toast. I helped him through his diarrhea and got frustrated when he broke Christmas ornaments. I watched him as he slept.

My answer to those people who say that is this: I absolutely get attached. I wonder where they are now. They visit me in my dreams, and sometimes I wake up with a wet face. It hurts. Sometimes in those moments, it hurts to breathe. You know what I know even *more*, though? I'd rather these sweet babies know my love than never know it. I would carry their hurt inside my own adult heart if it meant there was less in their tiny, sad ones.

There is absolutely no reason that an eight-year-old who watched his mother be murdered not know the love of a stranger. It's absolutely criminal that a two-year-old sit in a social worker's office for two days in dirty clothes because I'm afraid I'd get too attached. I got attached. Getting attached has been the greatest pleasure and honor of my entire life. **—RACHEL HILLESTAD**

J.M.: I'm so sorry, but believe this: he will *never* forget you. They may be distant memories when he's older, but they will never go away. I know this because I lost my son at the same age because of my drug addiction. I'm happy to say that I have him back, and I'm ten years clean, but he still remembers the kindness and love within his foster family, and I'll forever be grateful for that. He didn't have to be scared and alone, wondering if his mommy loved him or not, because they gave him so much love and made sure that he knew that even though I was sick, I still loved him very much. I still stay in contact with them; I owe them everything. It takes a very special person to be a foster parent.

in need of winter boots

I WENT to the Chicago Bears game today. We spent $32 total on

the train fares, $200 for our tickets, $7 for a hot dog, and $41 at
Giordano's Italian restaurant after the game. We paid that much
money to spend a fun day in the city even though it was cold. I feel
guilty. We have much more than what we need, and we don't even
have half of what most people have.

The high today was 30 degrees, so naturally I layered up in a lot
of clothing. I wore Under Armour pants and an Under Armour long-
sleeve shirt along with two additional pairs of pants, four shirts, two
sweatshirts, three pairs of socks, two pairs of gloves, a coat, a hat, a
scarf, and my favorite new pair of winter boots.

While we were inside Giordano's, I was very warm, so I took off
everything except my pants, socks, boots, Under Armour shirt, and
hat. I tossed it all into a bag, and when we left, I put on my coat and
carried that bag.

We had a short walk to the train station. As we were walking
across the street, I noticed a homeless woman crouched down trying
to stay warm. The "Walk" light appeared, and Sean, two of our
friends, and I hurried across the street to make sure we made it to the
train on time so that we wouldn't have to wait for the next one.

I got across the street and felt like I was going to throw up. I had
passed countless homeless people all day, but for some reason, I was
so drawn to this woman. I told my friends to please wait for just a
moment, and I tried to get back across the street quickly to talk with
this mystery woman.

As I approached her, I saw that her cardboard sign read, "I am in
need of winter boots and winter clothing items." Immediately, I knew

that this was providential timing and that I was supposed to give her the winter boots straight off of my feet.

I felt a little bit crazy because I was just planning on walking back to the train in just my socks.

I asked her what size she wore, and she said eight and a half. Same as me. I asked her what size shirt she wore, and she said medium. Same as me.

I had everything in that bag that she needed: shirts, sweatshirts, gloves, scarves, and so on.

The boots she was wearing were worn and wet. Mine were warm and waterproof.

I handed her the bag of clothing and winter items I had taken off at Giordano's, and also my leftover pizza, and told her that I would like to give her my boots.

She stood up and cried. I sat down with her, untied my boots, and slid off the top layer of my fuzzy, warm socks and handed them to her. She said they were the nicest shoes she'd ever had.

We exchanged names and a few other words. We looked about the same age. We talked a lot. Not through words as much as just by looking at each other. She looked worn and tired when our eyes first met, but by the time I left, I could sense the warmth of her personality and the thankfulness in her heart.

I started to walk away, and she said, "I don't want your feet to be cold. Can I give you my 'old' boots?"

She, who had nothing, offered me these boots. *Her* boots. I wore them all the way home.

Her name was Amy, and I just cannot stop thinking about her.

If you have the urge to do something kind for someone, I want to encourage you to do it. **—KELLY McGUIRE**

MY AMAZING eleven-year-old

son, Christian, wanted to fly his birth mom and sister to Utah to see them for the first time since he came home ten years ago. He also wanted to pay for it all by himself. He had the idea of setting up a lemonade stand to help reach this goal. He sat outside our house on three different days selling lemonade and cookies. The number of people he had come by was amazing! What we thought would be a fun little thing for him to do to start saving money for the visit far exceeded our expectations. In less than a month, we were able to have his birth mom and sister fly from Alabama to Utah for a visit! Not only had Christian raised enough money for the plane tickets, but he also paid for everything we did while they were here.

I am so thankful that my son has two moms who love him more than anything. Adoption is a wonderful thing!

—MONICA GILBERT

245

MY NIECES, Makayla, ten, and Madison, eight.

Kayla was diagnosed with Rett syndrome days before her second birthday. This rare neurological disorder has taken her voice and the use of her hands; it has given her seizures, as well as breathing, cardiac, and digestion troubles.

Madison was asked what she would buy with $100. Her answer was a "cure for my sister," and her drawing was of her "KK" with a cup labeled "cure"— complete with a straw because Kayla has lost the use of her hands.

This is love.

—MARCI POLEY-KWIATKOWSKI

246

a grateful mother

TO THE WOMAN in the Salina, Kansas, McDonald's bathroom:

You heard me as I reasoned with a three-year-old to use the bathroom.

You heard me tell her we had a long drive home and she needed to use the potty. You heard her tell me she was scared the toilet would flush while she was sitting on it. I couldn't convince her that I would block the sensor and keep that from happening. She promised she could hold it in and wouldn't pee in the car.

Then you stepped in. You told her you would give her a bracelet if she would go potty for Mommy. She perked up and agreed. I turned to quickly put her on the potty before she changed her mind. You told her the bracelet would be waiting outside the stall for her. I turned to say thank you, but you were already gone.

Outside the stall was a bracelet and a mini Snickers bar.

Her eyes lit up as she put on the bracelet after using the bathroom.

We made it home to Wichita safely, and she is currently sleeping soundly next to me—still wearing the bracelet.

Thank you for your kindness! I wish I could have thanked you in person, but maybe you will see this. If not, hopefully it inspires someone else to be kind like you were.

Sincerely,

A Grateful Mother

—TIFFANY MILLER

THIS IS GARRICK, an employee of Southwest Airlines

working flight 1264 flying from Orlando to Newark on Friday, July 8. Holding his arm is my nine-year-old daughter, Gabby, a type 1 diabetic with severe flying anxiety. Upon takeoff he noticed she was struggling. Throughout the flight he tried to make her laugh and brought her special drinks. As we got closer to our destination, the weather became rough, causing some turbulence. Then, Gabby began having a complete panic attack on descent. Garrick came up to her and asked if she would like his company in the empty seat next to her. I was flying without my husband

and with Gabby's younger siblings, so I couldn't leave my row; in the photo she's holding my hand from across the aisle. She happily accepted his offer. He suggested they talk to distract her from thinking about the plane landing, so they talked around half an hour about everything from his daughter (who is the same age as Gabby) to her pets to what grade she'll be entering. When extremely rough turbulence caused her to cry and grab his arm, he gently told her she could hang on as long as she needed to. This stress made her blood sugar crash dangerously. He left to bring her some orange juice and came right back to sit with her. She asked if she could continue to hold his arm while the plane landed. He, of course, agreed. Once we were on the ground and the plane was taxiing to its gate, Garrick announced on the intercom that his friend in the front row, Gabby, overcame her fear of flying and asked for a round of applause. Every passenger clapped for her. It was a wonderful experience on Southwest. We are forever grateful to have met such a beautiful, selfless soul. **—ERIKA SWART**

I ALWAYS

hear about fathers taking their daughters on dates, but parents must not forget about their sons! I started taking my son on dates when he was five. Not only is it so much fun spending quality time with him, but it's even more fun teaching him how to be a gentleman. He opened my car door and the front doors to the theater. I had him order our tickets and popcorn, including letting him complete each transaction by paying for them too. After we left, I didn't even have to remind him to open the doors for me. He excitedly ran over to the car and opened my door! I realized we needed to stop for gas and explained that it's always nice for the man to pump. So—under my supervision—he paid for and pumped the gas. He had an amazing time and asked to go on more dates with me. Not only do we need to show our daughters how to be treated and tell them what to look for in men, we also need to teach our sons how to be the men our daughters are looking for. Don't forget about our sons. They're just as important.

I now observe my son holding doors open for everyone, not just girls. But when he does hold the door open for a woman, he always says, "A gentleman always lets a lady go first."

—BRITTANY ROSS

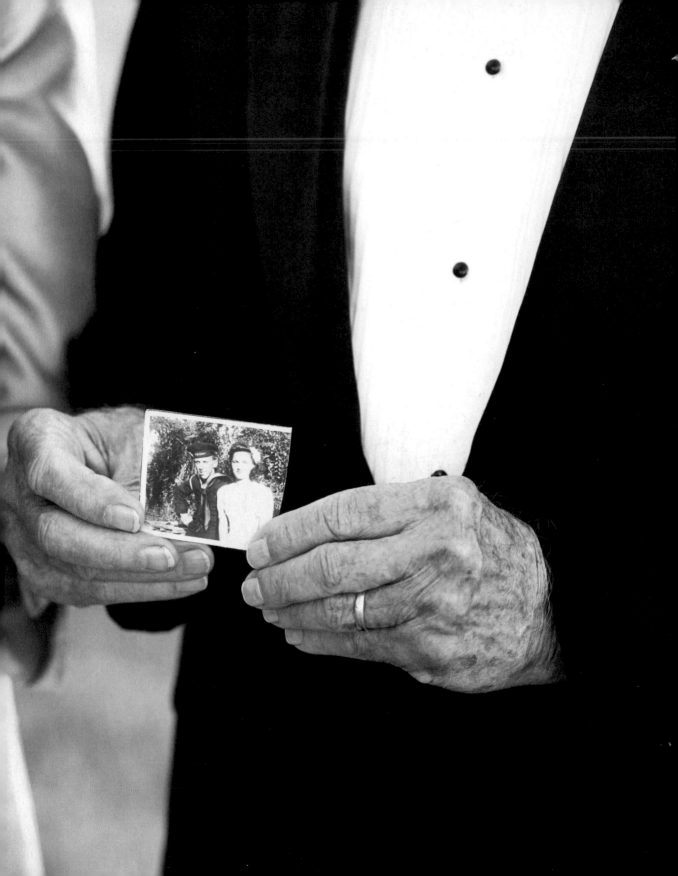

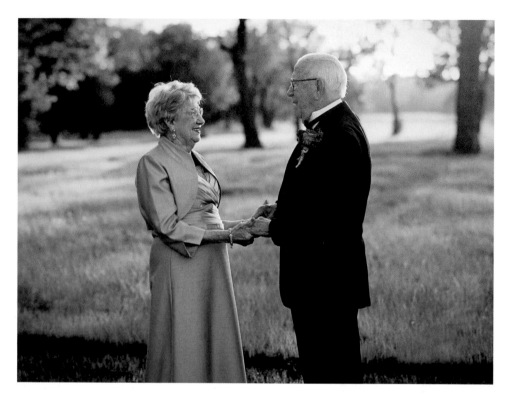

YOU CAN SEE the love between them in the way

they interacted with each other and laughed together as we would go from the different poses. They are a beautiful example of what marriage is meant to be. They still live in the same home they built for a growing family sixty-five years ago. They didn't have lots of money, but they had lots of shared values: the love of children, a good work ethic, a strong faith in God, and a sense of humor.

—LARA CARTER, TO THE *HUFFINGTON POST*

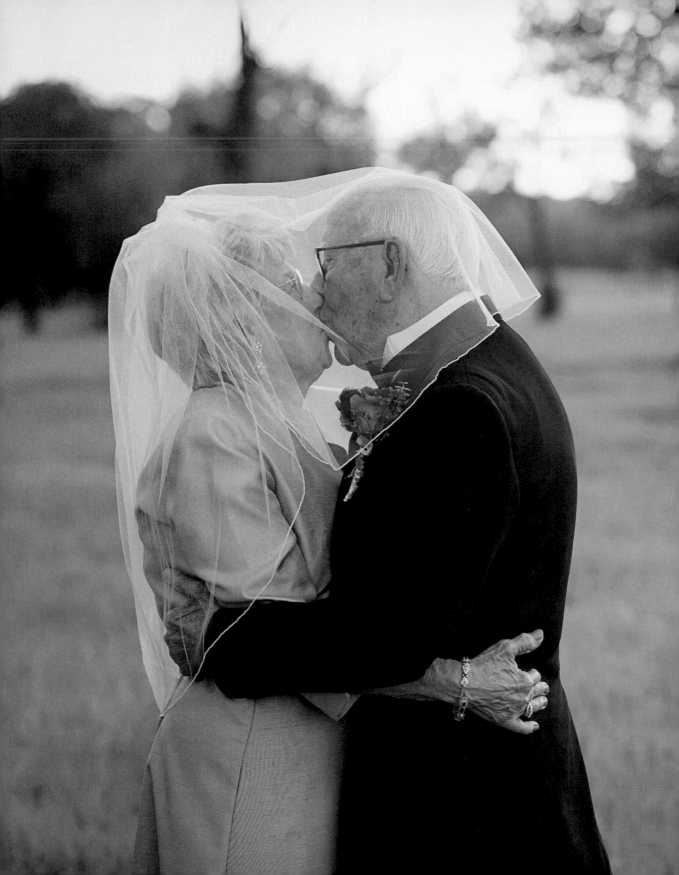

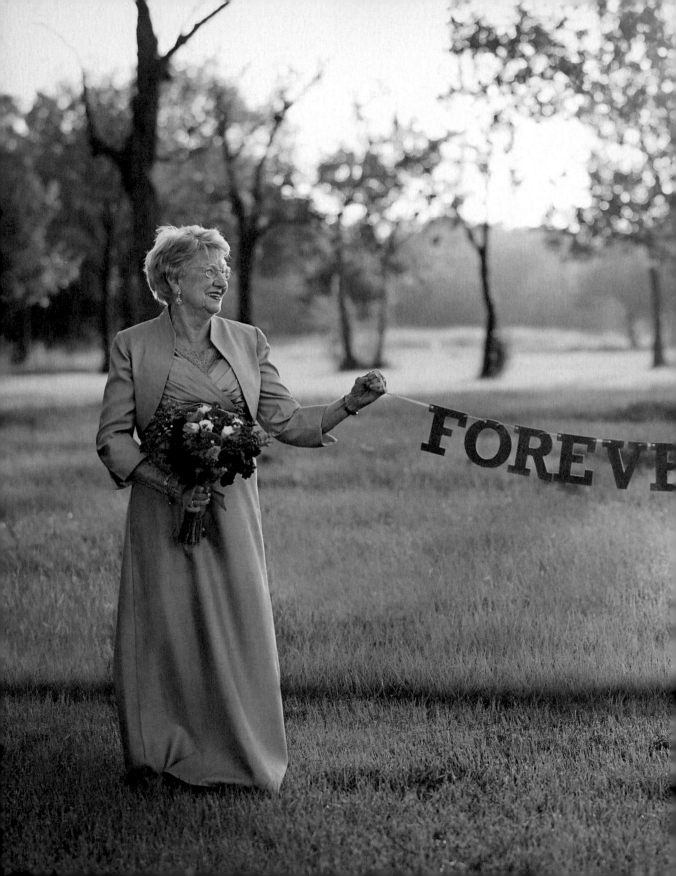

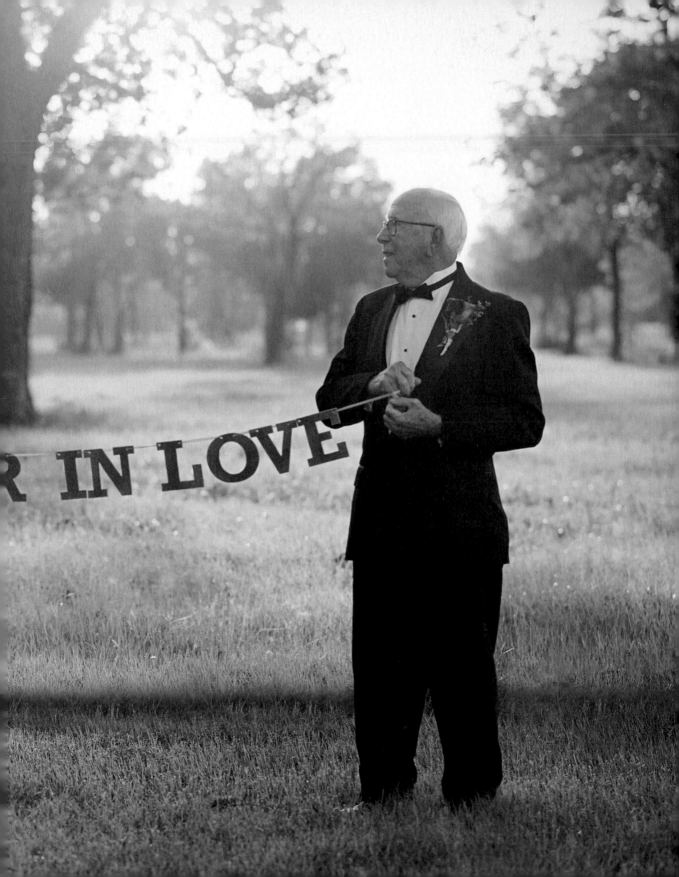

PHOTOGRAPHY CREDITS

1: Joanna Scheuerman

2–3: Alyssa Heiser

5: Ashtyn Ruysch

7: Roger Niehaus

8–9: Candace Caldwell

10: Amanda Madonna

11: Alicia Wade

13: Kelsey Van Fleet

19: Danny Wakefield

20–21: Samantha Boos Photography; comment photograph by Kim Davies

23: Joshua Walker

24: Rachel Pedersen

27: Finian Road Image & Design, LLC

28: Erin Lovewell

30: Kristine Kinninger

31: Tyler Ver Vynck

33: Madeline Schmidt

36–37: Brandi Guillet; comment photograph by Miranda Sharp

38–39: Alice Wack, Aja L. Fournet

40: Jennifer McCafferty

41: Karen Walsh Mount

43: Raquel Riley Thomas

44: Libby Sanders

45: Kayla Miller

46–47: Danielle Vinson

49: Shannon Daughtry

50: Kaylin Berlinguette

51: Ashlee Beck

52: Deric Wortham

55: Betsy Giron

56–57: Lynne Budnik

58: Amy Palmer

59: Michelle Randall

61: Shaina Murry

62: Sarah Thompson

65: Lindsey Burchfield

67: Kara Lewis Newton

68: Jerina Edwards

70: Kevin Taylor

71: Deb Mills

72–74: Johanna Morton

76–77: Courtesy of Sha-Ree' Castlebury

78–79: Lyndsey's PhotoCo

80: Trisha Bell

82: Regan Long

84: Briar Lusia McQueen

85: Erin Fedele

87: Kristin Charter

89: Alexandra Kilmurray of motherbynatureblog.com

90: Cesia Baires

92–93: Nikkole Paulun

94: Sunshine Moody

97: Wilma Garrett

99: Ashlie Molstad

100: Rachael Burow

103: Ernest Freeman

105: Angi Pietzak

106: Cynthia Clausen

107: Amy S. Pokras

109: Daeja Carson

111: Brandalyn Porter

113: Courtesy of Kirsten Nowak, Ally Ferreira

114–115: Casey Scarff

116–117: CeeCee James; comment photograph by Katie Bertram

119: Tonya White

120: Lisa Rooms

122: Gabriel Willford

125: Raelene Humphrey

127: Adara Johnson

128: Alex Guin

PHOTOGRAPHY CREDITS

129: Judy Dechert Rose

130: Kathleen Tarzwell

132: A. Jacobs

133: Kristen McCulloch

135: Mary Horsley

137: Carrie Cash, Senior Home Companions

138: Gem Salter

140–141: Laura Floyd; comment photograph: Jon Daniells

142: Kelly Wilson Bossley

143: Brittney Smith

144–145: Justi Bates

147: Ashley Wadleigh

148: Dallas French

149: Courtesy of Brittany Hilton

151: Nadine Shelley

155: Cierra Fortner

156: Whitney McGraw

159: Amanda Boyer

161: Ariel McRae

163: Courtesy of Kerry Magro

164: Lisa Jane Fudge

166–167: Jacque Austin Photography

169: Candace Whited

172–173: Crystal Hodges; comment photograph: Krista E. Day

174: Courtesy of Lesley Miller

176: Kristin Sherman

178: CoCo Photo

181: Adele Flannery

183: Synthia Therese Photography courtesy of Bethany Jacobs

184–185: Christina Julian

187: Courtesy of Brynne Huffman

188–189: Courtney Mixon, J. Addison Safely II

190: Erin McCarthy

191: Lezlie Bauler; comment photograph by Danielle Lanigan

193: Sarah Bigler

195: Darion Gudeman

196: Chantal St. Peter

198–199: Courtesy of Diana DeBernardis

201: Mary Walls Penney

202: Mel Watts

205: Cipriana Greek

207: Courtesy of Regan Long

208–209: Caitlin Fladager

210: Courtesy of Victoria Vargas

211: Jenna Woestman

213: Stephanie Skaggs

216–217: Holly Wright

218–219: Amy Clary

220: Kelly Dirkes

223: Leland Schipper

225: Brandon Potter

226: Stefanie Helms Powell

229: Adora Nuttall of www.facebook.com /savingluke

231: Jennifer Campos

232: Ryan Wilden

235: Pamela De Almeida

237: Katie Pugh

239: Matt Mager

241: Rachel Hillestad

242: Kelly McGuire

245: Monica Gilbert

246–247: Marci-Poley Kwiatkowski

248: Tiffany Miller

250: Erika Swart

251: Brittany Ross

252–257: Lara Carter Photography

260: Keshara Rosser

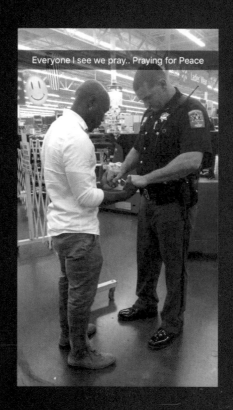

Everyone I see we pray.. Praying for Peace

WHAT THE WORLD NEEDS NOW IS LOVE.

—AVERY ROSSER